DIGITAL manga

DIGITAL manga

BEN KREFTA

ARCTURUS

Ben Krefta is a freelance illustrator and graphic designer based in the UK. He creates unique, unconventional artwork aimed primarily at tech-savvy, video game-playing, manga-reading teens and young adults.

 Ben has published several bestselling how-to-draw manga books and worked on a number of art and design projects for websites, game developers and magazines. He has also delivered digital art demonstrations for clients such as Hitachi and Wacom. For more information, visit his homepage, *www.organicmetal.co.uk*.

ARCTURUS

This edition published in 2014 by Arcturus Publishing Limited
26/27 Bickels Yard, 151–153 Bermondsey Street,
London SE1 3HA

Copyright © Arcturus Holdings Limited

ISBN: 978-1-78404-046-8
AD003946UK

Printed in China

Contents

WELCOME TO THE DIGITAL AGE!

In recent years, the production of artwork has shifted towards the use of computers and image-making software, as they make the job of creating, colouring, editing and reproducing artwork fast and easy. Therefore, while there will always be a place for traditional pencils and paints for those who appreciate them, digital art is here to stay.

I've been displaying my work on the web since the late 1990s. Ever since then the main question I've been asked is: 'How do you colour your artwork?'. For me, neither online tutorials nor many of the books on the market delivered a truly in-depth guide to the artist's working process, so I decided to produce a book of my own to answer that question. My plan was to put together a comprehensive and inspirational guide that would teach every little trick I'd learned over 12 years of using Photoshop, and would show its practical application to character art. *Digital Manga* is the result!

The book's primary aim is to teach you how to use Photoshop as a tool for creating and colouring your artworks. Its secondary aim is to provide guidance on choosing colours and handling light and shade. It will help you explore your full potential by showing how to combine your existing hand-drawn artwork with the latest graphics software to create fully rendered, eye-popping character designs.

Anime, manga and game characters come in all shapes, sizes and styles. *Digital Manga* includes favourite genres which help illustrate the various tutorials throughout the book. For example, the War Games section (see pages 110–117) demonstrates techniques such as how to add a camouflage pattern to clothing and give the image a dirty 'post-war' effect. Other characters show how to easily create realistic textures, add backgrounds, insert speech bubbles and lots more. So, in effect, each character is a project consisting of several mini-tutorials.

The tutorials in *Digital Manga* are obviously created with anime and game fans in mind but, whatever your interests and art style, the information within these pages will benefit all novice digital artists. Each step-by-step tutorial includes an in-depth explanation to ensure that you enjoy following the entire process and can produce your own professional artworks without difficulty.

While the book teaches things the way I do them, it doesn't mean this is the only way to work. If there are other artists whose colouring styles you admire, you can base your work on theirs or experiment to create your own style. Once you've gained a good understanding of the basic technical processes, you'll want to have fun with them and do your own thing.

Digital Manga will help you to:

▲ Eliminate paper use and create characters on a computer

▲ Use Photoshop as a colouring tool

▲ Get the best results for scanning and enhancing your line work

▲ Choose the right colours and apply them to different character illustrations

▲ Place shadows and highlights for the most realistic and dramatic results

▲ Produce stunning effects in minutes and implement an array of time-saving tips

▲ Create anime 'cel'-style images and a silky-smooth shaded look

▲ Achieve professional results time after time

WHAT IS MANGA?

Manga is a term used to describe comics created in Japan or produced by Japanese *manga-ka* (cartoonists), primarily for a Japanese audience. The style was developed in the late 19th century and draws heavily on influences from Western comics combined with ideas taken from Japanese art and wood-block prints. In the West, the term 'manga' is often used to describe a particular style of Japanese drawing and art as well as a type of Japanese comic.

Manga comics are typically black and white, but manga art and anime (a term describing animation created in Japan) is often produced in full colour. Many modern manga-style artists have fused a variety of Western styles into their artwork. They have also used idiosyncratic colouring styles, such as a flat-tone 'cel' effect and a soft airbrush style, together with more traditional painterly effects. A cel, or celluloid, is a transparent sheet on which characters and props are hand drawn or painted for 2D animation and cartoons.

In recent years manga art, video games, comics and other aspects of Japanese culture have become popular with Western audiences. Comic and pop culture shows and conventions are often attended by devoted fans sporting costume play ('cosplay') outfits of their favourite manga and game characters, and search terms such as

'Naruto' (the eponymous main character of a current manga series) are yielding almost as many results on Google as 'Batman'. Among online art communities, many people both young and old want to emulate the style of their favourite anime TV shows and video games, and the simplified manga style has a lot of appeal. This art then evolves into more polished and professional-looking work, which inspires the next generation of artists to aim for a similar standard.

Most digital character artists start with line art, which they then colour and render in the style they like best. While generic anime style might be recognized by its 2D animation cel style, and manga by a more black-and-white inked style, many manga and anime artists, online and published pros alike, produce a soft, shaded style of colouring which has an airbrushed look to it. Japanese artists sometimes refer to this as manga CG (computer graphics). Some opt for a painterly style to mimic watercolours, markers or acrylics. Most of my work fuses an anime CG with Western comic colouring and I like the colours to look deep and vibrant, rather than subtle and washed-out. However, while I teach the styles I use in this book, I encourage you to explore and find a style that suits you.

WHY ARE CG AND DIGITAL COLOUR SO POPULAR?

Contemporary anime and manga are now a staple of the film and game industries and have increasingly diversified, as have the methods of creating them. Traditional pen and ink is rapidly being replaced or combined with graphics software, which allows artists to experiment with colour and new techniques without the mess, cost of materials and extra time demanded by conventional methods. Many of us are being brought up in a techno-gadget-driven society and are on the way to realizing visions of artists like Masamune Shirow in his mangas *Appleseed* and *Ghost in the Shell*.

It's an exciting time to sample the new software and hardware constantly emerging on the market. Home computers have reached a stage where things work fast and efficiently, and long-standing software packages such as Photoshop have evolved to a point where the majority of users would be hard-pressed to think how to improve them. Certainly, Photoshop CS6 does everything I need and has come a long way since I started using version 4 back in the late 1990s. Now there's nothing to stop us creating anything our imaginations can conceive.

Here are some of the advantages to working digitally:

▲ You have unlimited canvases, paints, brushes and materials at your fingertips

▲ After the initial outlay on computer, tablet and software, the cost of producing art is minimal

▲ You can save your work at different stages and go back to edit it

▲ You can achieve super-flat colours and precise gradients

▲ With textured overlays, you can instantly change the look of artwork

▲ You can upload and share artwork on the internet

▲ You can easily print and reproduce your work

▲ The software can help artists with shaky hands; shortsighted people can zoom in on their work

▲ You can create perfect lines and curves

▲ You can easily resize, duplicate or reposition bits of your artwork

▲ You can UNDO at any time!

CHAPTER 1
TECHNOLOGY BASICS

Photoshop is a graphics software application created in the early 1990s and designed for photographers and image editors. Today, artists and designers from all backgrounds, including most of those working in the comic-book, film and video-game industry, use Photoshop CS (Creative Suite) and Photoshop CC (Creative Cloud) as artistic tools.

While you may already be familiar with basic Photoshop functions, there is much more to this program than simply cropping and adjusting hue and contrast levels. This chapter shows you how to begin unleashing Photoshop's full potential when it comes to character creation and colour rendering.

Chapter highlights

▲ Setting up and understanding computer specs and software

▲ Using graphics tablets

▲ Exploring the Photoshop workspace

▲ Deploying Photoshop tools

▲ Working with layers

▲ Understanding image file types

SETTING UP: HARDWARE

If you're starting out in the world of digital art, it's important to know about the hardware you need before delving into the intricacies of Photoshop.

To begin with, all you require is a mid-range computer, monitor, keyboard and mouse. But if you've got some cash to spend and want to make the most of your digital colouring, it's a good idea to invest in a high-end PC or Apple Mac. Photoshop is a very resource-hungry program and a high-spec system helps to avoid it crashing or slowing down when you're working with large files.

Many industry professionals, especially those involved in graphic design, use Apple Macs, which generally perform better and look nicer than a typical PC set-up. However, PCs with the same internal specifications as Macs are usually a lot cheaper and are what most home users own. My advice is just to use a computer you're familiar with, whichever type that may be. I used a desktop PC for many years, but now high-end laptop specs can compete with those of desktop computers. A good laptop offers me the freedom of portability along with enough power to work on large Photoshop files, even while my media player, the internet and other apps are running in the background.

Computer specifications

Adobe requirements for Photoshop:

Operating System: Microsoft Windows 8 / Mac OS X v10.8

Multicore CPU with 64-bit support (2GHz or faster)

1GB of RAM

1024 x 768 display (1280 x 800 recommended) with OpenGL® 2.0, 16-bit colour, and 512MB of VRAM (1GB recommended)

3.2GB of available hard-disk space for installation; additional free space required during installation (cannot install on removable flash storage devices)

Internet connection and registration are necessary for required software activation, membership validation, and access to online services

My own requirements for Photoshop at the time of writing:

Operating System: Microsoft Windows 8

A speedy Quad Core Intel processor with 64-bit support (2.4GHz)

16GB of RAM (DDR3, 1600mhz)

1920 x 1080 full high-definition display with OpenGL® 4.1, 32-bit colour, and 2GB of VRAM

I house Photoshop and my OS on a 250GB solid state hard drive and have a second 2TB drive for general file storage

The internet is handy for sourcing reference, patterns and textures and for sharing artwork on the web

Computer component facts

Before you go out and buy the best computer you can find or upgrade components on your present one, there are some things you need to consider.

First, not all CPUs (central processing units) are what you might expect – a higher model number doesn't always mean better performance. For example, an Intel Core i7-3930K @ 3.20GHz speed performs better than an Intel Core i7-4770K @ 3.50GHz. Whenever I'm about to purchase a new computer system or processor, I like to see how it compares with other computer specs. Checking out CPU benchmark tests on the internet is a good way of determining how well your computer will perform.

It's also desirable to have a big (at least 1TB), fast (at least a 64MB cache) hard drive to store and access all your files. If, like me, you use a solid-state hard drive, this is even better for fast loading times.

For most Photoshop work, a high-end gaming graphics card isn't necessary and won't make your art look better or help Photoshop run significantly faster. When it comes to selecting a graphics processor (GPU), I recommend you research the price of both top- and bottom-end cards and go for something in between, with OpenGL support. A decent GPU should help on those occasions when you're loading, rendering or previewing resource-hungry Photoshop filters such as Blur and Liquify.

RAM

The more RAM you have, the better; this will help you to work on larger file sizes as it will reduce loading and lag time when using tools and processes, and potentially avoid the program crashing or freezing. Photoshop allows you to customize how it uses RAM and other hardware resources (see page 18).

32- and 64-bit processors

Older computers may use a 32-bit processor and/or run a 32-bit version of the operating system. On a Windows machine, Photoshop CS6 installs both a 32- and 64-bit version of the software (as do CS5 and CS4). CS3 and lower versions are 32-bit only. If you have a 32-bit computer you'll only be able to access up to 3.2GB of RAM on your machine and CPU operations will run approximately 10 per cent slower.

Photoshop version	Windows version	Maximum amount of RAM Photoshop can use
32 bit	32 bit	1.7 GB
32 bit	64 bit	3.2 GB
64 bit	64 bit	as much RAM as you can fit into your computer

On a Mac, Photoshop CS6 installs in 64-bit mode only. If you have a 32-bit Mac and OS, you need to install a version of Photoshop earlier than CS6 (such as CS4 or CS5) to run it, and you will then be limited by the amount of computer memory you can access.

Basically, if you are able to run 64-bit, go for it! The only time I switch to 32-bit is to access my TWAIN scanner, as it will only work fully with 32-bit versions of Photoshop. It's important to note that 32-bit plug-ins and filters installed in Photoshop will only work when the 32-bit version of Photoshop runs; similarly, the 64-bit version is needed to run 64-bit plug-ins and filters.

Workspace

I've been using the hardware set-up below for a while now, since switching from a desktop to a laptop computer.

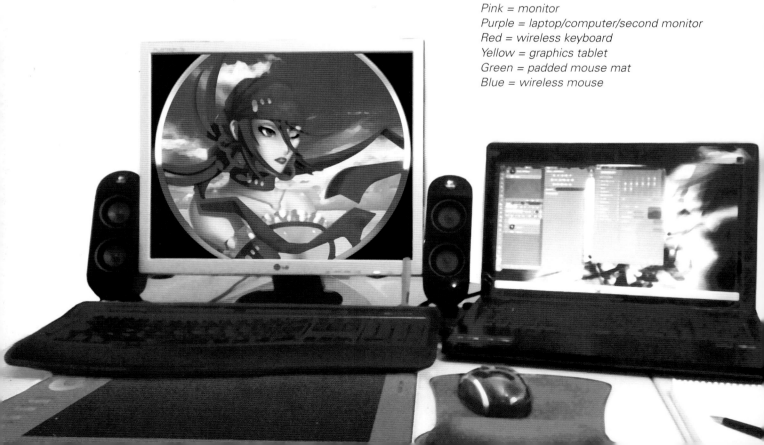

Pink = monitor
Purple = laptop/computer/second monitor
Red = wireless keyboard
Yellow = graphics tablet
Green = padded mouse mat
Blue = wireless mouse

Monitor

Look out for a good-quality high-definition monitor. Flat LCD and LED screens are the norm these days, but prices vary hugely with the top-end displays ten times more expensive than those at the lower end. The screen you use can make all the difference, so don't try to save money by getting a cheap one as colours and tones simply won't look right. I typically work with a dual-view set-up with two monitors, which allows me to use one screen for my main canvas and another screen for Photoshop's tools, palettes and tabs (see pages 18–23).

Printer

If you want to print your work, a decent inkjet photo printer with good-quality photo paper should produce satisfactory results. I have an Epson A3+ printer with six different inks that can be changed individually, instead of replacing a multi-colour cartridge. If I need hard copies for clients, for my portfolio or for prints to sell, I tend to go to my local print bureau to get a top-quality result.

Scanner

A flatbed scanner is an essential and fairly inexpensive piece of equipment for any digital artist. I use a Canon A4 scanner with 2400 x 4800 dots per inch (dpi) scan resolution and 48-bit colour depth, which suits my needs perfectly. If you tend to work on slightly larger formats such as A3 paper, investing in an A3 scanner would be useful as it saves you having to scan your work in multiple parts (see pages 52–3).

GRAPHICS TABLETS

Once you've become familiar with some basic colouring techniques, ditching the mouse in place of a graphics tablet (consisting of a pen-like stylus and surface) is the way forward. Not only will it help with precision cursor movements and allow true, freehand CG-ing, it will also speed up the colouring process and even help to avoid the repetitive strain injury that can result from using a mouse for prolonged periods.

Graphics tablets take some time to get used to. I had to practise for a good month or so before I became comfortable with my first Wacom Intuos, so don't be discouraged if it seems a clumsy way of working at first.

What should I buy?

To start with, you could buy one of the cheaper tablets and see how you like it before investing in a pricier model. Alternatively, you could go for something with a higher price tag as it will save you having to make a second purchase further down the line. I was fortunate enough to get my hands on a more expensive tablet from the start and it has served me well for years.

Brands such as Aiptek, Genius and DigiPro have a good range of tablets, but Wacom have built up a solid reputation for tablet technology and most professional digital artists couldn't imagine working without one. The Wacom Intuos Pen is an entry-level tablet with an active area of 152 x 95mm (6 x 3.7in), while the Intuos Pro is a professional tablet with increased levels of sensitivity. It comes in a range of sizes – I use a Pro Medium with an active area of 224 x 140mm (8.8 x 5.5in).

The Wacom Cintiq Pen Display allows you to work directly on the tablet screen. The transition from pen and paper to a Cintiq is easier than to an Intuos. However, the Cintiq requires a separate power supply and many people still prefer using a traditional tablet with a separate screen. The Cintiq 13 is a great portable solution, which can easily be transported in a laptop bag, while the Cintiq 24, weighing in at nearly 29kg (64lb) with a stand, is for desk use only.

Tablet tips

Tablet pens often come with a choice of nibs – regular plastic, spring-loaded or fibre. You need to set up your pen according to your own preference. I like a nib that creates a degree of friction on the tablet surface so that the pen tip doesn't slide about in an uncontrolled way. A plastic nib will last quite a while before it needs replacing, although I prefer the feel of the fibre nib when using a Cintiq.

When setting up your tablet, you can customize your preferences via the Properties menu. I have the tilt sensitivity set to normal and pressure sensitivity at 20% soft, since I don't like to press down on my pen too hard. I leave the double-click distance in the middle. Just experiment until you discover what suits you best.

Tablet buttons can be customized. I set the front button (closest to the nib) as my eraser as this saves time flipping the pen upside down whenever I want to erase. I set the back button to right-click. So far as mapping goes, using the full surface area is fine most of the time, but if I'm working with a dual view set-up with two displays side by side I tend to map just the bottom 50%. This ensures that the mapped area fits in a more proportional ratio with the display surface and the pen cursor travels at the same speed both horizontally and vertically. If mapping is left to the full area, the cursor tends to travel more slowly vertically and faster horizontally.

INTRODUCTION TO PHOTOSHOP

While Photoshop CS6 is great as an artistic tool, many of the techniques in this book can also be implemented with earlier versions of Photoshop or applied to other art and design software, such as Corel Painter or Paint Tool Sai. Most digital art programs share similarities such as canvas and brush set-up, painting onto layers and so on.

When I first started using the computer to colour my line art, I didn't appreciate that it would take practice and knowledge to get the results I wanted. I hoped that Photoshop would instantly make me a better artist, but while it can save time compared to drawing and painting with traditional media, it's important to realize that Photoshop can't do the creative work for you. Achieving a stylish, slick artwork still takes skill and knowledge, such as how to proportion a human figure, what colours work best together and where to place shadows.

The workspace

Setting up a workspace to suit your own preference helps to familiarize you with Photoshop's layout of tools and palettes. I generally set up my workspace to look like the images on the page opposite. If using a dual-view set-up with two monitors (my typical set-up), I will have my main canvas on the left display in front of me, and the tools and tabs on the screen on the right.

If you don't have much experience using Photoshop, I recommend spending time familiarizing yourself with the various options in the Menu Bar. Once your workspace is set up you can save it by clicking the Workspace icon near the top right.

Setting Preferences

Edit / Photoshop –> Preferences –> General [Ctrl+K / Cmd+K]

I leave the majority of settings as they are. In File Handling, I make sure that 'Save in Background' and 'Automatically Save Recovery Information Every' are checked and I set the latter to save every five minutes. The Autosave feature in CS6 is one of the best software upgrades Photoshop has seen for years.

In Performance, I set my RAM usage to 90–95%. This allows Photoshop to make use of all that extra RAM on my machine should I need it and still leaves enough to run background system programs. I allow Photoshop to make use of my hard drives as scratch discs – this basically means that when the computer does not have enough RAM to perform an operation, it will use the disc as virtual memory.

Keyboard shortcuts

Edit –> Keyboard Shortcuts [Alt+Shift+Ctrl+K / Opt+Shift+Cmd+K]

Undo is one of the most useful shortcut keys when dealing with digital artwork or computers in general. By default, Photoshop's Ctrl+Z / Cmd+Z toggles between the Undo and Redo commands. I prefer Ctrl+Z to be set as the shortcut key for Step Backwards so that every time I enter Ctrl+Z, my artwork reverts to its previous state. Ctrl+Y is Step Forwards, since I'm accustomed to using Ctrl+Y to step forwards with software such as Dreamweaver and Word.

I also like to swap Ctrl+B to Brightness/Contrast and Ctrl+H to Hue/Saturation, as I use these two adjustment tabs more often and it makes more sense to me.

Next on the Keyboard Shortcuts tab you'll notice a tab for Menus. I find it handy to colour-code some of the menus I use most often to make it easier to find them while working. For example, under Image –> Adjustments, I'll make Brightness/Contrast, Hue/Saturation and Replace Color as red, as I use these most often, and I will set Levels, Vibrance and Color Balance as orange, as I use these occasionally. Under Select, I'll set Modify and Expand to red because I use this a lot, as you'll see in later chapters.

Once you've set any relevant keyboard shortcuts and Menu settings preferences, you can save these by clicking the relevant icon next to Set at the top.

Menu bar

Canvas

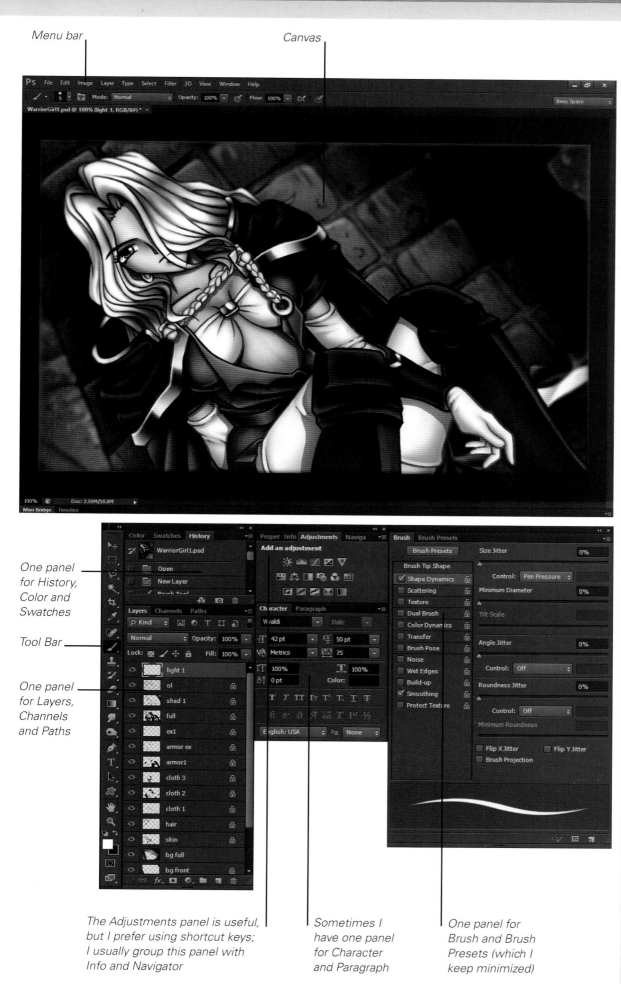

One panel for History, Color and Swatches

Tool Bar

One panel for Layers, Channels and Paths

The Adjustments panel is useful, but I prefer using shortcut keys; I usually group this panel with Info and Navigator

Sometimes I have one panel for Character and Paragraph

One panel for Brush and Brush Presets (which I keep minimized)

PHOTOSHOP TOOLS

The Tool Bar has been consistent in Photoshop and other art and design software for years, so you'll probably be familiar with this type of interface. First, I recommend checking out the Tools overview via the Photoshop Help website (F1). Some of the icons contained in the bar are important, others less so, but the majority can be used for art purposes and I'll be explaining the tools in relation to the digital artwork tutorials in this book. To access additional tools, click and hold the cursor on icons with the small triangle in the bottom right-hand corner.

Move tool (V)

This tool moves selections, layers and painted areas – it's useful if you're copying and pasting parts of an image.

Marquee tools (M)

These can be used to select parts of an image or create square borders on completed artwork by filling in the selections. The Elliptical Marquee tool is good for drawing circles – hold down Shift while creating the circle selection to make a perfect circle. To create an outline from your selection, go to Edit –> Stroke (or right-click the selection Stroke) and choose the line width. The colour of the line will be the same as the primary colour selection, unless you change it.

Lasso tools (L)

As selection tools, Lasso and Polygon Lasso are used a lot for 'cuts' and 'cel-style' solid tones (see page 63). The Magnetic Lasso is rarely used for digital art. If you don't have a graphics tablet, you'll spend more time using the Polygon tool, since the Freehand tool can be tricky to use with a mouse. This is one of the three possible tools/methods I choose for laying my initial base tones – after making a selection, I fill it with colour. I often amend my selections: if you've made a mistake, instead of starting a new selection, hold down Shift to add extra selections to your initial one – this is a very handy trick to learn. Use the Alt/Opt keys to take away part of a selection. You'll notice the minus and plus symbols next to the cursor as you hold down the keys.

Magic Wand tool (W)

Don't be fooled by the name, it won't do your art for you! Instead, it creates selections which fill similarly coloured areas. I mostly use it when I'm working from clean, inked lines to lay flat base tones. With the wand selected, click the area within your drawing, then go to Select –> Modify –> Expand and select a pixel expansion value. Expanding the selection will avoid a filled flat tone looking scummy round the edges. At the resolution I work at, I'll usually expand an extra 4–8 pixels and make sure my selection doesn't go over the lines. Very thin lines may not work with this method and you may need to add with the other selection tools; that is, by holding Shift and using a Lasso to get at areas the wand can't reach.

Crop tool (C)

Use this to trim your finished art, or if your scanned art needs clipping back. You can also use it to expand your canvas.

Eyedropper tool (I)

I generally use this tool every time I colour to pick tones from my artwork. With the Brush tool selected, hold Alt/Opt and the brush changes to the Eyedropper (this avoids having to toggle between the Eyedropper and the Brush tool). Other tools in the Eyedropper tab, such as the 3D Material Eyedropper or 123 Count, aren't necessary. However, I do sometimes use the Note tool, which allows me to write reminders of how I want certain elements to look – then I attach them to my image file.

Healing tool (J)

Use the Healing tool to repair or retouch images. It is also great for photo-editing and can also be used to fix patterns in texture overlays.

Brush tool (B)

The most frequently visited tool in the bar, used for laying down initial flat tones or rendering those tones. The Brush tool is used in conjunction with the Brush tab to simulate painting with a paintbrush. By adjusting brush settings such as Opacity and Flow, you can make Photoshop simulate an airbrush effect – something I like to use to colour my artwork. Brushes can be adjusted to hard for more solid tones or soft for airbrush shading. To keep lines as smooth as possible, set the brush spacing to 1% on the Brush tab. Pencil, Color Replacement and Mixer Brushes aren't necessary for this kind of art.

Clone Stamp tool (S)

This paints with a sampled part of an image. I never use this, nor do I use the Pattern Stamp tool, which paints with a pattern defined from your image, another image, or a preset pattern.

History Brush tool (Y)

I seldom use this tool. It makes a copy of the image as it was in a previous state, then uses the content of this copy to paint with.

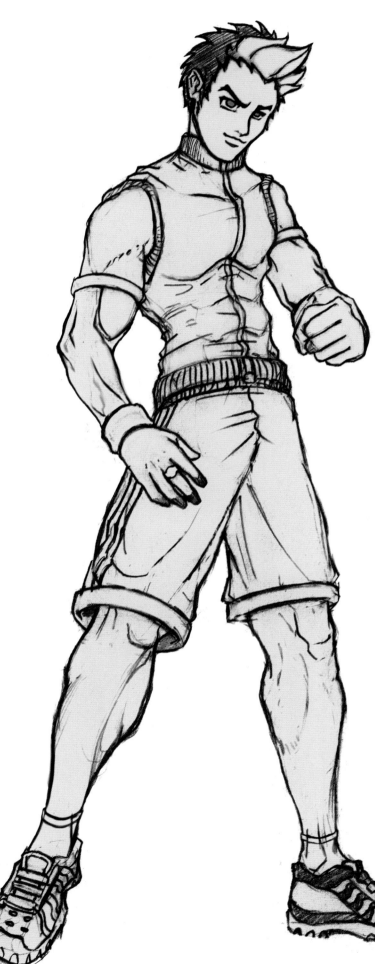

Eraser tool (E)

This tool effectively works like a brush and I turn to it a lot. A good tip is to use it on a locked layer tone so that the secondary colour selection is used instead of an area being deleted. It saves time swapping and picking a second colour with a brush because I have my tablet pen button (not end) set to eraser.

Gradient tools (G)

Don't rely on these instead of an airbrush. I use a Gradient fill for part of a background or colour overlay (see page 58). It's also the best way to fill areas quickly rather than using the Paint Bucket fill tool, which can leave an unwanted thin outline of pixels around certain objects or selections.

Blur tool (R)

You may want to use this occasionally to help blend out unwanted pixels.

Sharpen tool (R)

(The same icon as Blur.) This sharpens the soft edges of an image. I have hardly ever needed it and have never found it particularly effective compared with Sharpen Filters.

Smudge tool (R)

(The same icon as Blur.) While it's handy for putting a shine on hair or fabric, this tool takes a lot of RAM. If you have set a big Smudge brush size, and you smudge an area for a long time, it may take several minutes before the smudge is fully applied to a high resolution image. Use it sparingly.

Dodge tool (O)

I've seen people achieve excellent results with this tool, which lightens a tone progressively the more times you click, but it gives less control than Brushes. If you want to experiment with it, I recommend using it on 50% pressure or less and applying it to mid-tones.

Burn tool (O)

(The same icon as Dodge.) The opposite to Dodge, the Burn tool darkens a tone the more you click it. While these can be fun tools to experiment with, using too much Dodge or Burn can often leave artwork looking muddy or over-saturated.

Sponge tool (O)

(The same icon as Dodge.) This alters the amount of 'pigment' or saturation on a shaded tone. I've never really needed it.

Pen tools (P)

Similar to the Polygon Lasso (dot-to-dot style selection), but you have a lot more control over it. Pen tools are often used for digital inking (see pages 48–49). The Pen allows you to control nodes and curves to create perfect lines. Using the Pen tool takes practice and experience to fully understand how to make the most of it.

Type tool (T)

For adding text, this tool is usually just employed at post-production stage, for details on a character or building or on top of speech bubbles.

Path Selection tools (A)

You will only use these if you want to move paths created using the Pen tool.

Shape tools (U)

These are great to use when working on websites and graphics, but I don't find them so handy for character art. The most important is the Line tool, which draws straight lines. To create a tapered straight line, click the Arrowheads setting icon on the tool options bar at the top and set the width to 100% and length at around 1000%. Tapered straight lines are great for manga-style action and speed lines. Hold down Shift for vertical or horizontal lines.

Hand tool (H)

For moving the canvas – the regular Hand tool works in the same way as holding the spacebar on the keyboard. I tend to use the scroller on my mouse to move up and down an image or I just use the scroll bars on the right and bottom of the window.

Rotate View tool (R)

(The same icon as Hand.) This tool is more useful than the Hand in that it allows you to draw smooth curved lines by pivoting your wrist or elbow (while using a tablet pen) after the canvas has been rotated. The view can be reset to normal after you've finished drawing in curves.

Zoom tool (Z)

Rather than Zoom click or Alt / Opt click for zooming out, I much prefer using the keyboard (Ctrl + or Ctrl −). I zoom in and out of my images a lot during the creation process, focusing in on details, then zooming out for the bigger picture.

Colour Selection tool

Use the X key to alternate quickly between primary and secondary.

Quick Mask (Q)

Creating masks is something I tend to save for graphic design and photography work.

Screen Mode (F)

This isn't necessary unless you want to avoid palettes and tools taking up screen space. I often press the Tab key if I want to toggle the tools and panels between 'hidden' and 'displayed' while I work.

WHAT ARE LAYERS?

Layers work like sheets of acetate or clear plastic. The lines you paint on one layer won't affect another layer in the Layers panel (see below). If you paint on a layer above you'll cover up the layer underneath, but you won't paint over it.

Go to the Photoshop Help site (F1) and read the extensive information on layers while experimenting on your own. Layers are a very important part of the digital process and you need to know how to use them and how they work.

By putting different colours on different layers you can shade each one without adding, for example, unwanted hair colour on a girl's face or skin tone on a guy's jacket. Each layer can then be edited individually at any time.

Shown here is the Layers panel for the Purple Princess (an original character created for a web-based project). It has three layers – Border and Pattern at the top, Character in the middle and Background at the bottom. If I wanted to draw on to the artwork, I would first need to select the relevant layer.

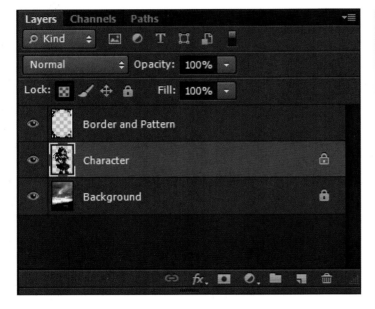

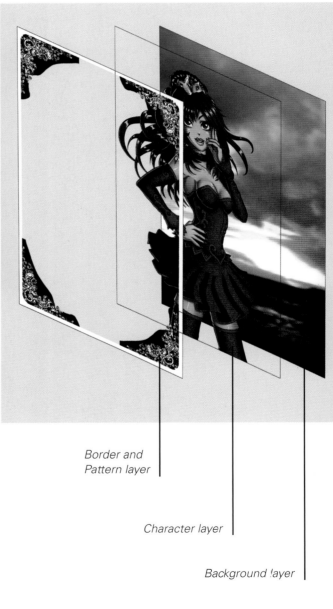

Border and Pattern layer

Character layer

Background layer

You can see that the Character layer is currently selected, as it's highlighted in blue. I have applied a transparent pixel lock to this layer, indicated by the clear padlock icon on the right of the layer title. This means I can only paint on to or edit pixels that are visible and not transparent; it effectively creates a mask, so I can't paint onto an area outside the character margins. The knowledge that you can't paint outside the lines or selected tones makes layers really helpful.

Notice that on the Background layer I have added a Lock All icon, indicated by the solid padlock icon next to the layer title. This means I won't accidentally paint onto or edit this layer. Once you start creating art in Photoshop, it's possible to build up a stack of layers and it's not uncommon to start painting on the wrong layer by mistake. To lock a layer, click one of the four lock icons next to the word 'Lock' on the Layers panel. I often find that 'Lock Transparent Pixels' and 'Lock All' are the only lock types I need.

Here I could draw straight onto the Border and Pattern layer if I wanted to, as it's not locked. All I need to do is click that layer, then begin drawing on the canvas space.

You can reorder layers by dragging and dropping them into a new position within the Layers panel stack. Note that when you import a new image or open a canvas in Photoshop, it will be shown as a less editable layer, named Background.
To convert it to a regular, fully editable layer, double-click the title and rename it.

I often use dozens of layers per artwork; in the long run, it can be a lot quicker to name them than to go through them all trying to find the 'purple cloth material' one, for example. You can rename layers at any time by double-clicking the layer's title.

SAVING YOUR IMAGES FOR WEB AND PRINT

New artwork needs to be saved as a file to prevent it from being lost once Photoshop is closed. Whether you're scanning work or creating a new image, you need to work on a high-resolution file with high dpi (dots per inch) or high ppi (pixels per inch). Then you'll want to make sure the end quality of the image stays as sharp as possible, whether it is printed or uploaded to the internet.

For a good-quality print, 300 dpi is the standard requirement, while 72 dpi is adequate for web use. However, I recommend always working on images with at least a 300 dpi resolution, since it's easy to scale down

artwork but impossible to up-scale without a degree of quality loss.

Check out your image size specifications by clicking Image –> Image Size [Alt+ Crl+I / Opt+Cmd+I]. Note that Pixel Dimensions corresponds with Document Size, so if I were to change my pixel width from 6300 to 63, my print size would result in a width change of 53.34cm (21in) to 0.5334cm (0.21in). Clicking OK would shrink the image and, although the dpi would remain a constant 300 dpi in a square inch, the image would now only be a little over a fifth of a square inch, if printed.

Image Size

Pixel Dimensions: 90.1M

Width: 6300 Pixels

Height: 5000 Pixels

OK
Cancel
Auto...

Document Size:

Width: 21 Inches

Height: 16.667 Inches

Resolution: 300 Pixels/Inch

☑ Scale Styles
☑ Constrain Proportions
☑ Resample Image:

Bicubic Automatic

If I wanted to print my image at double the width, 106.68cm (42in), I could upscale my pixel dimensions by doubling those values. Photoshop would then increase its file size to accommodate the extra pixels. If I didn't want to increase the file size of my image prior to printing, I could lower the dpi to 150 after unchecking the Resample Image box. Either way would result in a lower-quality print, so the larger the image size and resolutions you can handle, the less chance there is of reducing the image quality if you want to print at a large size. However, large files mean you'll need a large hard disk to house them and a computer with enough RAM to process and edit them, or you will risk computer and software crashes. If you know your image will never need to be printed large-scale or will only be used for the web, then it makes sense to work on smaller files to suit your needs.

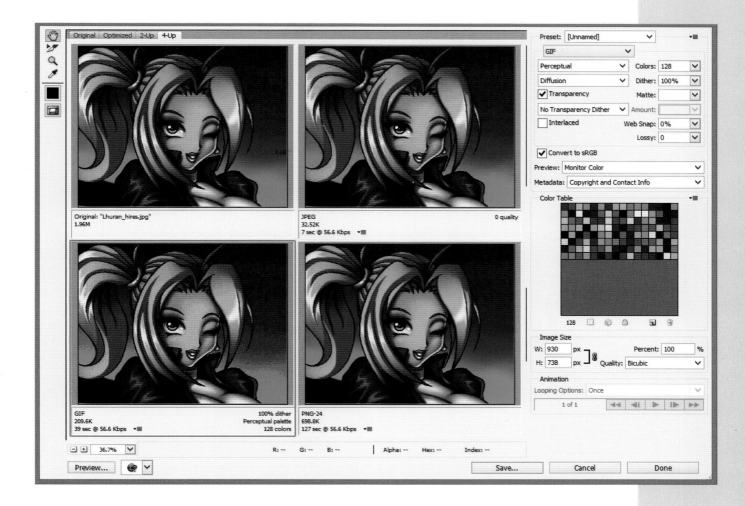

Formats

A saved Photoshop file is called a PSD and has a .psd file extension. It's a raw, uncompressed file format which holds all the information for different layers and Photoshop-related data. If you can handle files that are of large pixel dimensions and/or sizes above 2GB, you'll need to save your work as a PSD file.

If you do manage to create a 2GB+ file, it will probably be too large to attach to emails or upload to the web. After I finish creating an artwork I save it as a PSD; I then save a second web-size version for sending to clients by email or sharing on the internet.

To do this, resize the image to smaller pixel dimensions, for example from 6300 x 5000 to 1000 x 794. Then go through the familiar File –> Save as [Ctrl+Shift+S / Cmd+Shift+S] routine. Name your file and select Format, then choose JPEG. The image will be flattened and processed as a compressed, web-ready image. An image quality of 9 or 10 is usually sufficient to make it look acceptable on the web without generating a big file size. Image quality lower than this can show signs of compression.

When saving specifically for the web, check out File –> Save for Web [Ctrl+Shift+Alt+S / Cmd+Shift+Opt+S]. This allows you more control over how your web-ready file will look once it has been compressed as a JPEG, or you can use a smaller colour palette by saving as a GIF or PNG file.

CHAPTER 2
FROM CONCEPT TO CREATION

Now that you've gained an understanding of the software, played around with the tools and browsed all the menus, it's time to create character art! This section will cover sketching and conceptualizing straight on to the computer.

If you are planning to create a story, comic or game think about the qualities your audience will look for. They may initially want action, mystery and romance, but as time passes they will remember the characters you create the best, so take time developing some strong characteristics and making use of your digital canvas to sketch out ideas and concepts.

Chapter highlights

▲ Drawing figures

▲ Drawing heads

▲ Character design basics

▲ Drawing a face digitally

▲ Drawing a figure digitally, based on a photograph

▲ Digital inking

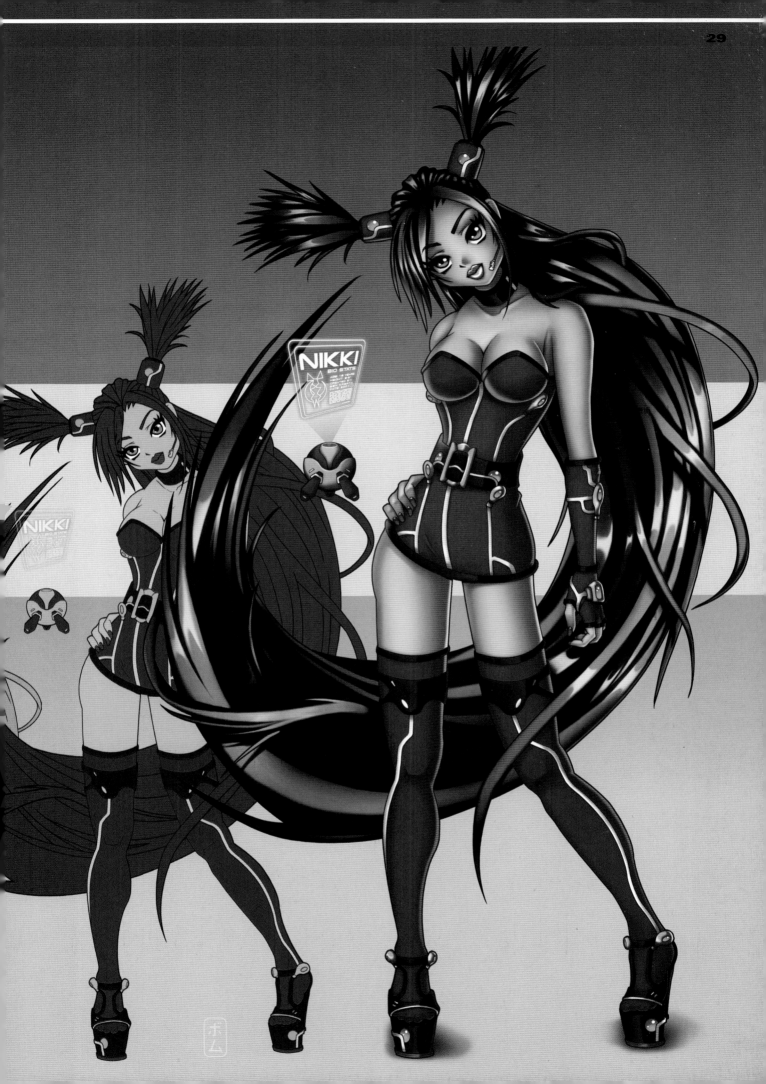

DRAWING BASICS: FIGURES

Whether an artist is painting traditionally, rendering digitally or creating three-dimensional models, learning how to draw is a invaluable tool. Before delving into fancy rendering and shading techniques it's important to understand how to construct characters in proportion.

After some practice, many artists instinctively know how to proportion their characters correctly. As a guide, a fully grown adult is usually between seven and nine heads tall and around three heads wide (at his or her widest point). Children are generally between three and seven heads tall. With comic art and manga, a moderate amount of exaggeration is used to help designs stand out. Drawing the human figure in proportion requires you to be consistently realistic while at the same time implementing your own artistic style. This is important if your characters are to be featured several times, throughout a comic strip, for example.

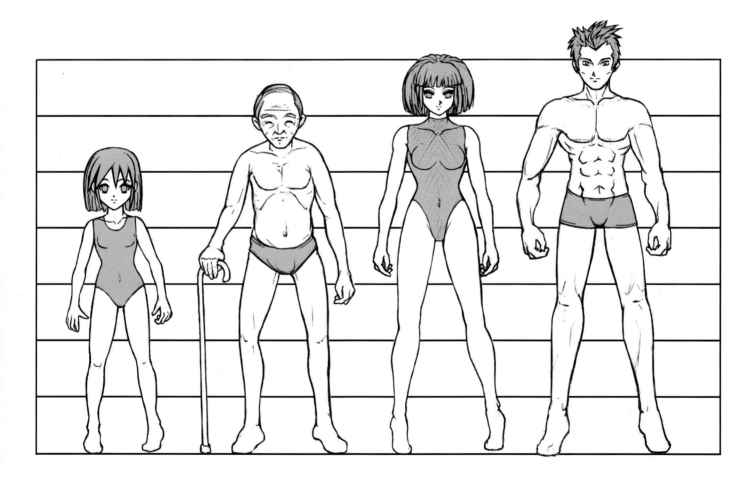

Construction

Adult male

Draw a vertical line down the centre of the page to keep things symmetrical, then create a wire-frame line drawing (I've used red in my example).

Flesh out the stick man with basic shapes (I've used blue for this).

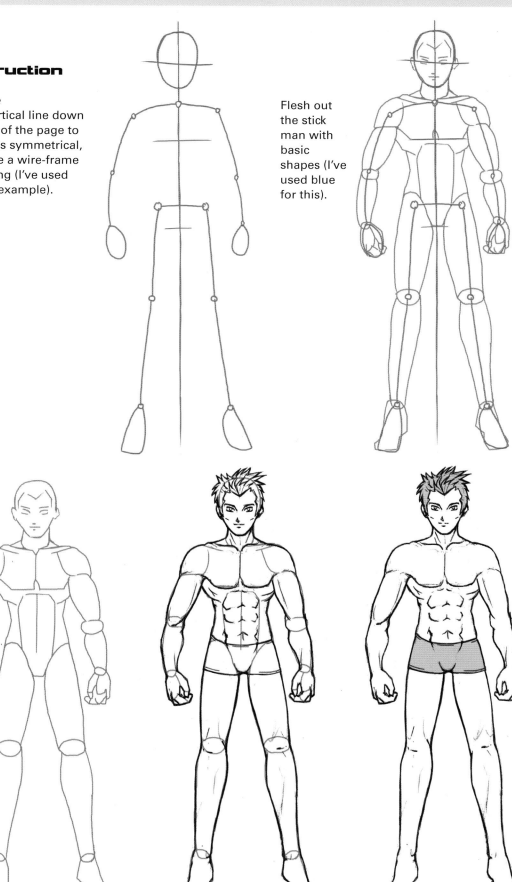

Gradually add in details and define the various body parts. Between each stage, use an eraser to delete any construction lines that are no longer needed. Realistic styles often use tone and shading to define form and body parts. In many Western comics, line hatching and solid black block shading are used to add depth. But manga is all about line work. The characters are usually kept sparse at the initial stage, with shading and tone added later on using black and grey screen tones or colour.

Adult female

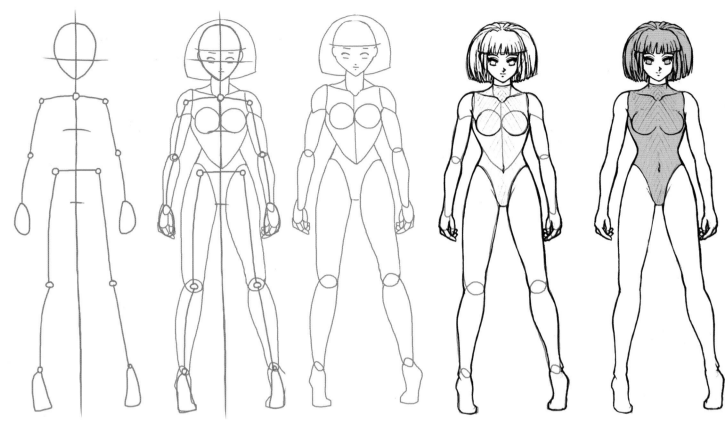

Manga art focuses a lot on the eyes, which can be used to great effect to convey a wide range of emotions. Manga females have exaggeratedly large eyes and small mouths.

Boy

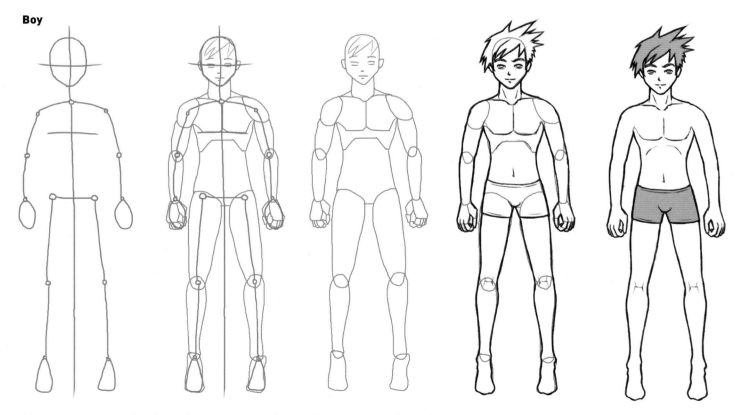

Young males can also have larger eyes to denote innocence and youth, but most males and older characters tend to have smaller, narrower eyes.

Girl

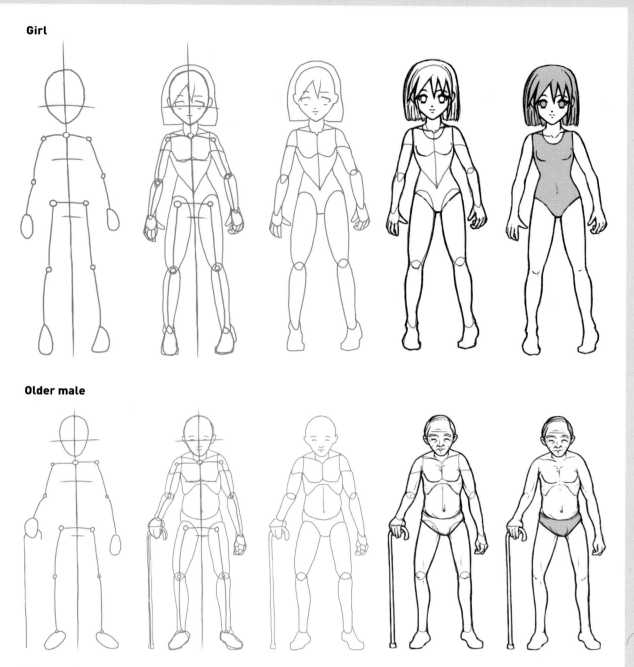

Older male

Manga characters are usually leaner than their American and European comic-book counterparts. Their costumes vary greatly, but tend to be less tight-fitting than the clothing you may associate with, for example, Marvel and DC Comics.

Poses

To make poses look a little more dynamic and less rigid, I often start with a sweeping curve or 'S' shape upon which I build my character framework. Following an 'S' often throws the hips forwards or to one side and makes the figure look more interesting. Here's an example of how I quickly sketch out a pose and proportions based on a single curved line, then tighten it up by considering the muscle groupings.

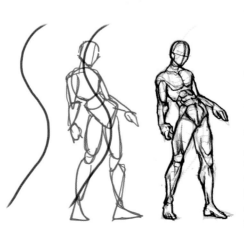

When it comes to anatomy, it's really a case of practising life drawing and studying books or other artists' work to see how they do it. Manga-style artwork is often simplified and doesn't include certain muscle detail you would find in a typical American superhero comic. Once you've learned what muscles go where and how big or small they are, you can transfer that knowledge to any style of artwork.

DRAWING BASICS: HEADS AND FACES

Faces are the most important part of any character artwork – even if the rest of your work is a little sketchy and rough around the edges it's still important to refine the facial details.

These pages show how to apply the same fundamental technique of using guidelines to construct different types of heads and faces.

Basic female, male and child heads

There is more to manga than big eyes and small mouths. Depending on your style of artwork, the faces and ways in which you proportion a head will differ.

As a general rule, female faces tend to be a little wider, with a smaller, more pointed chin. The eyes are bigger than for males.

With older characters the space between the eyes and mouth is often deeper.

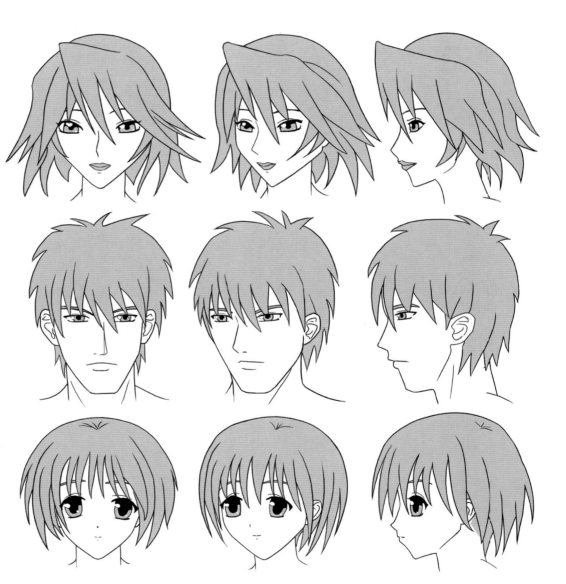

Younger characters often have bigger eyes and a small nose and mouth.

The personality of a character can be reflected in the face, especially by adjusting the eyes and eyebrows.

Rotating the left eye slightly clockwise and the right eye anti-clockwise gives an assured, mean look. Conversely, slightly rotating each eye the opposite way produces a cute, innocent look.

Many manga characters don't have lips – just a line indicating their shape. However, if a character is wearing makeup, draw in the lip outline.

Construction

Here red and blue lines are used to show where faint pencil or tablet guidelines go. As with the full-figure examples on pages 30–33, these are mostly removed as you progress through the drawing.

Female front view, step-by-step

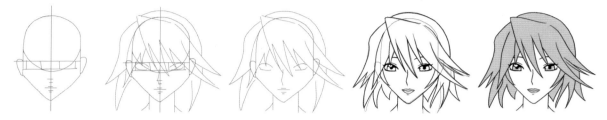

Front views are all about keeping things symmetrical. Begin with a circular shape divided by a vertical line down the centre of the face, then put in perpendicular lines to mark out where the eyes will be. It's important to remember that the gap between each eye will be roughly the same width as the eyes themselves.

Once the guidelines are in place, you can fill in details such as the eyes, mouth and nose. When adding hair, keep the shape of the head in mind so you avoid making the hairline too low or too high.

Male three-quarter view, step-by-step

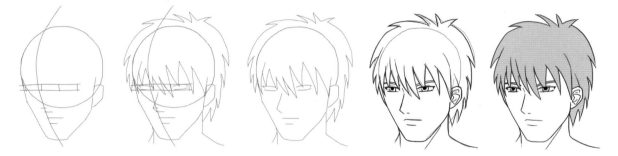

In a three-quarter view, the head is twisted to the left or right, causing one side of the face to narrow. Start with a circular shape and divide it with a vertical line down the centre – note that this line curves because of the angle of the head. The jaw comes in slightly. As before, mark where the eyes will go with guidelines.

The next step is to add the hair – short and spiky always goes well with guys – and place the eyes within the guide boxes before erasing the guides.

Child side view, step-by-step

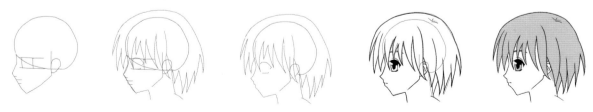

Side angles require you to draw a flattened circle shape, then a box at the lower corner where the jaw will be. The ear is situated at the bottom centre of the flattened circle, between the nose and eyebrows. Starting from the base of the nose, mark in three parallel lines equal distances apart to indicate where the mouth and bottom lip will be. Chisel out the subtle shape of the lips and nose and make sure they follow the same diagonal direction of the guideline.

As with the previous examples, the final steps are to fill in the eyes and make any last-minute adjustments before removing the guidelines to reveal the finished character head.

Construction of additional face styles

By applying the same step-by-step principles of using guidelines to plot facial features, you can create a multitude of characters in various styles. These examples are a little more detailed, but they still use similar construction methods. Remember that the guidelines are important to ensure that the eyes are parallel and the features symmetrical.

Front view

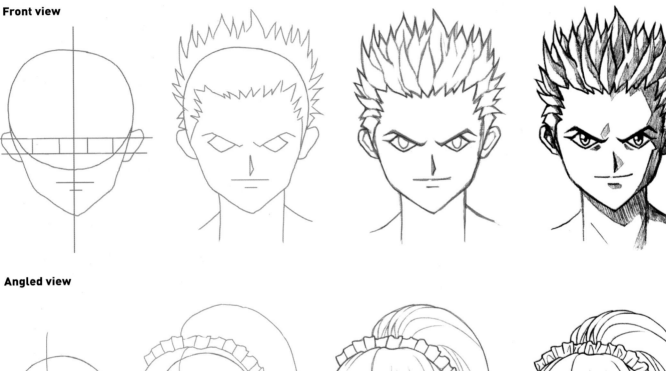

Angled view

Three-quarter view

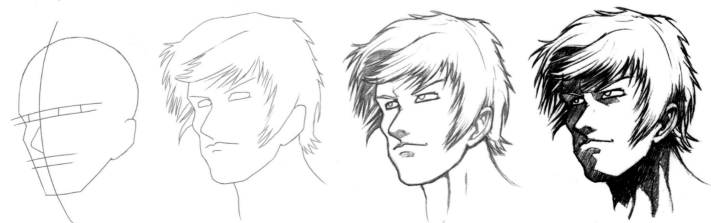

Faces come in all shapes, sizes and styles, and while they may be one of the trickiest things to draw, they're also the most fun. You can find a wealth of facial expression references on the internet; it's also worth looking through comics and manga to see how other artists portray emotions for different scenes.

FINDING IDEAS

When creating characters, there are an infinite amount of ideas to explore. Hyung-Tae Kim, one of my favourite game artists, uses fashion magazines for outfit inspiration, while Masamune Shirow, another favourite of mine, turns to nature and insects for many of his robot and mecha-inspired designs.

While it's great to be inspired by existing comics, movies and games, you should avoid simply rehashing someone else's idea. But there's no harm in surrounding yourself with things you think are cool and inspirational. Sci-fi-inspired fashions and characters are my thing, so I love checking out the latest sci-fi blockbusters or video

games and creating something like that in my own style.

I source character poses from the internet, magazines, photos and real life. There are even sites on the internet which offer 3D character models in hundreds of different poses which can be rotated in different angles. This allows you to use them as a base for your design if you can't draw poses from your imagination. Some artists can construct a figure using a mental library of previously drawn poses, or build a figure based on basic anatomical knowledge. I prefer loosely basing character poses on photos. Here are a few quick concept sketches I created.

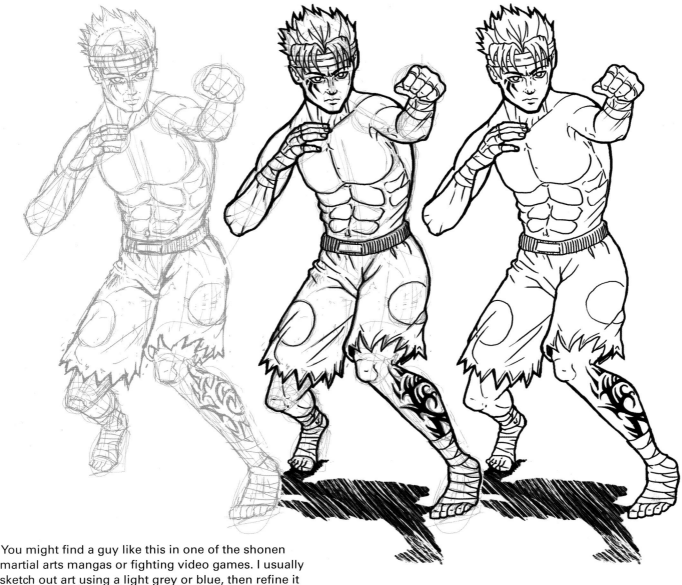

You might find a guy like this in one of the shonen martial arts mangas or fighting video games. I usually sketch out art using a light grey or blue, then refine it by using black on a separate layer above. I can then delete the sketchier layer beneath, leaving me with a nice neat drawing minus the initial construction lines.

The gynoid (female robot) character below is loosely based on manga star Astroboy. I wanted to place her in a seductive sitting pose and used foreshortening on her leg to create a dynamic perspective. Sometimes I work straight on the computer, using a black or grey brush like this.

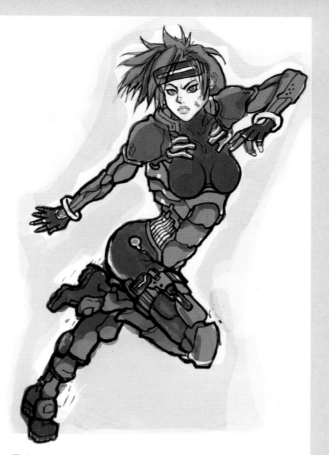

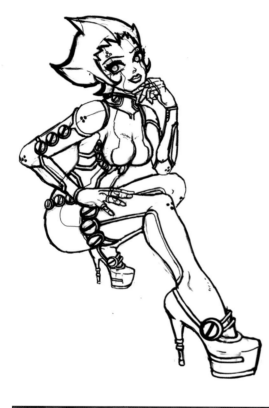

This cyber-armoured girl's pose was based on a simple 3D character model. It's a little more lively than a straightforward standing pose. I filled it in with some quick grey tones, keeping her armour pretty dark compared with her face.

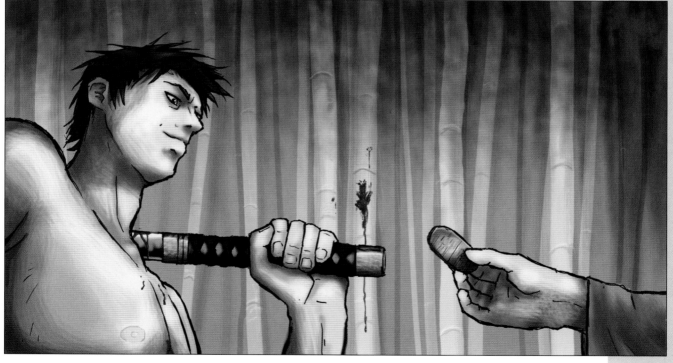

The lone warrior takes a pay-off for doing someone else's dirty work. This sketch was given a quick dash of colour. I use a tablet sketch like this when I want to experiment with a few basic colour tones before moving on to a more polished version.

CHARACTER DESIGN BASICS

When designing a character from scratch, it can be hard to know where to start. I advise thinking of a theme or feature that the character will represent and making it bold and exaggerated. From there on, it's a case of deciding how best to design your character to serve a purpose, compared to doodling generic figures and hoping something evolves from that (although this process can be fun too!).

Ice wizard

This character is an intellectual who spends his time researching and educating himself about spells and such – I want him to be physically capable, but he is unlikely to spend all day training and sculpting a heavy weapon-wielding physique. If he's a master rather than an apprentice, he's likely to be older and confident in his abilities, so an upright, shoulders back, relaxed stance would suit. If he's a goodie, a calm and relaxed demeanour works, as opposed to a manic look! Consider what kind of environment and world he'll be based in. Maybe a type of *Lord of the Rings* fantasy setting or perhaps something a little more unconventional and modern – and, if the latter, how would a spell-caster operate in a modern setting?

Remember to consider:

▲ Physique and age

▲ Personality – facial expression and pose

▲ Outfit and accessories

The setting can determine his personality and outfit style. As he's ice-based, blue and white clothing is an obvious indicator of his purpose; or you could make his body mostly covered in ice-proof material to avoid becoming frozen by his own spells. A spell book or potion accessories would also suggest his role.

Here's a quick, coloured tablet sketch along the lines described. You can see how I started with a sketchy drawing, which I refined a little more, adding in some basic colours. I'd still consider the coloured version as a rough – something I'd later rework, amend and tighten up.

Drawing style

Style is something that usually develops over the course of an artist's career. It's a natural way of producing artwork that stems from the many influences the artist has absorbed over the course of his or her life. As far as line work goes, you might like a sketchy look to your characters, or you may prefer neater outlines and smooth shading, as I do.

The way you proportion your characters and the flourishes you add to your image vary dramatically from artist to artist. This is what determines the style of an image. I often like to adapt my style of artwork to suit different briefs and to avoid getting stale. However, nearly all my work exhibits some form of manga influence. Manga art can be broken down into hundreds of sub-genres and pseudo-manga styles, but there are always tell-tale signs of its Japanese origins, be they the thin line weights, the shape of the eyes and nose, the hair, the pose or outfit theme.

So if I wanted to draw the Ice Wizard in a more child-friendly 'chibi' style, he might look something like the version shown on the right. Basically it's a case of simplifying his features, enlarging the head and shrinking the body to produce a squished-down version.

Magical girl

The magical girl manga sub-genre features school-age kids who typically gain supernatural powers through a magic object or sceptre. To illustrate how outfit and accessories can give a generic figure an identity and purpose, I decided to create a female character and start with a back story to explain her persona. She's Hana (meaning flower in Japanese), a shy, retiring schoolgirl who tries her best but doesn't have many friends and isn't particularly popular. One day she goes for a walk in the woods and discovers a magic sceptre hidden in the undergrowth which transforms her into a super-powered hero! It's a little clichéd, but why not? The sceptre makes her confident, outgoing and energetic, so I've started by drawing a typical manga girl leaping through the air.

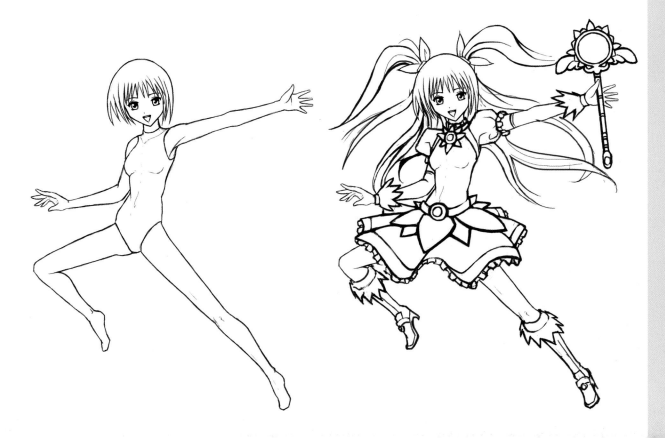

Sticking with the whole elements idea, I've assigned her an earth element, and to suggest that she gains her power through nature I've given her a dress with a petal theme and coloured her with earthy greens and browns.

Often the mark of a good character is its silhouette. This should be obvious and easily identifiable. If you are creating a cast of characters, try drawing just silhouettes to start with. When the characters are assembled, make sure each silhouette is distinguishable from the others.

Alternate views

When designing a character, it's a good idea to consider how it appears from different angles. This example shows the front and back of a figure. Side and three-quarter angles are also useful for helping to get a fuller understanding of how your character works as a whole.

Thumbnails

Small, speedy, rough sketches can be drawn before
attempting a more finalized drawing. These can
be used as a way to experiment with how certain
poses, features and elements might look once
translated from brain to canvas before jumping into
a more detailed drawing.

FACE SKETCH

Here's a step-by-step of how I use Photoshop to sketch, starting with a character face. I usually do numerous face sketches when trying out new drawing styles.

I wanted to make this one a fairly generic, tough-looking guy you might find in shonen (boys') or seinen (mature guys') manga.

STEP 1

With Photoshop open, start by clicking File –> New. You'll be presented with a box allowing you to customize your canvas. Start by writing the name of the file. In this case I've named it 'Face1'. This will be used as the file name once it is saved. I number every new file I create with a 1 in case I want to save separate second or third versions. Click the box where it says 'Custom' and choose International Paper and Size: A3. I tend to work with metric values, but you can use imperial, if you prefer, for the width and height. Select a 300 dpi resolution, and set colour mode to CMYK as this image is going to need good-quality printing.

I sometimes work in 16-bit colour mode, as opposed to 8. Other than increasing file size, what does this mean? 8-bit colour uses a tonal range of more than 16 million colours while 16-bit uses trillions! On its own, it doesn't make a difference since our eyes couldn't see that many colours anyway, but the reason I use 16-bit is so that image quality is sustained when tweaking contrast levels on artwork. Otherwise there are occasions when, if contrast is increased, a gradient tone can become slightly broken up and staggered instead of remaining smooth.

Set Background Contents to white (or transparent) and click OK.

STEP 2

If the Background Contents are set to white, double-click the layer named 'Background' and rename 'Layer 0' in the dialogue box as 'Background'. This will 'unflatten' the layer, converting it to an unlocked, usable state.

If the Background Contents are set to transparent, first fill the background layer with white. This makes sketching easier to see than on the transparent grey chequerboard background. To do this, select the Paint Bucket tool, make sure white is selected as the primary colour and click on the canvas to fill. Apply 'Lock All' to the background layer to make it uneditable.

STEP 3

Create a layer on top named 'Construction lines'. This will be the base for creating a face. Using the Brush tool, select a 9-pixel round brush with 100% hardness and 1% spacing, then check the shape dynamics box, which will be controlled using the tablet's pen pressure. On the brush options bar at the top, set the flow percentage to 6%. Alternatively, the flow can be kept at 100% and brush opacity can be reduced to around 35%. This will create a pencil-like brush with which the lines can be darkened by going over them a second or third time. At this stage it's a good idea to set up the Eraser –> Select Eraser Tool and choose a 19-pixel, hard, round brush. I usually keep the flow and opacity at 100% for the eraser, but lowering either of these values can work too.

STEP 4

Make sure the 'Construction lines' layer is selected and the Brush tool is once again selected. Then click the primary/foreground colour on the tool bar to bring up the Color Picker screen. Select a blue tone and click OK. Alternatively, select a blue from the Swatches menu panel.

STEP 5
Now you're ready to start
making marks. Lay down the
usual facial construction lines
to work out proportions.

STEP 6
Then try to give the face a little more
form and detail. Any stray lines can be
removed with the eraser, by clicking
the tablet pen button if you have
customized it as I do (see page 17).

STEP 7
Once you have finished with the blue, it's then
easier to refine the drawing by sketching over the top
in black. To make the blue lines even less visible, simply
adjust the layer's opacity to something like 50%. Next, add
another layer on top, name it 'Refined lined', then select a black
for the foreground colour and set the flow a little higher, to 12%, before
you start. Remember this is just a sketch, so don't spend too long retracing
over the top and refining. You can zoom in to the image with Ctrl + / Cmd +
or zoom out with Ctrl – / Cmd – to improve accuracy when adding details.

A BODY SKETCH USING REFERENCE

This time I'm going to draw a full-length character and show you how to use a photo as reference. First, source an image of a dynamic jumping pose. You might want to search the internet for royalty-free stock images, look in magazines or books or take photos of your friends or yourself in the mirror. In this example I just wanted a pose to work from, but you might want to look for a photo with stronger shadows or better lighting which can help if you go on to colour in the artwork.

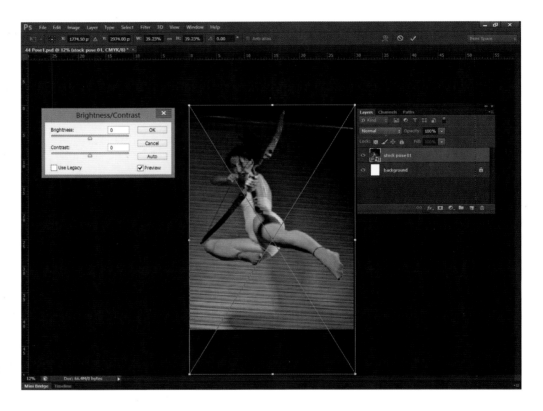

STEP 1

As with the previous sketch, start by setting up an A3 canvas at 300dpi (which works out as 3508 x 4961 pixels). Drag the stock image from the computer desktop on to the Photoshop canvas, then use the corner nodes to resize its dimensions and click the little 'check' icon on the Properties bar or press Enter to confirm. The photo is now placed on a new layer as Smart Object. This means that the image can be resized later without potential quality loss, though the layer is not fully editable. However, you can Rasterize the layer at any time, converting it to a fixed pixel dimension object which can then be fully edited like any other layer. To do this, right-click the stock pose layer and select Rasterize. Alternatively, the reference image can be opened directly in Photoshop and copied and pasted onto the new canvas.

If needs be, from here the photo's brightness or contrast levels can be increased to make the details easier to pick up when tracing. Select Image –> Adjustments –> Brightness/Contrast [Ctrl+B / Cmd+B] and play around with the sliders, with or without Legacy mode, until you are satisfied with the result and then click OK.

STEP 2

Adjust the stock pose layer to around 25% opacity and create a new layer at the top called 'line art' which will be your 'tracing paper' layer. This time I'll be working onto the line art layer only, but you can use a blue or light grey brush as before to mark in the proportions and anatomy, and then refine. Try to keep the tracing light and sketchy as the photo is only a rough guide.

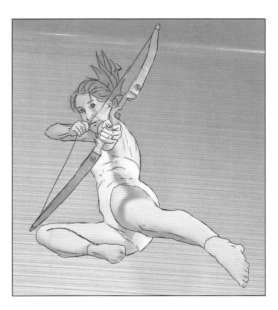

STEP 3

Once the basic lines are laid down, hide the stock pose layer by clicking the eye icon next to it.

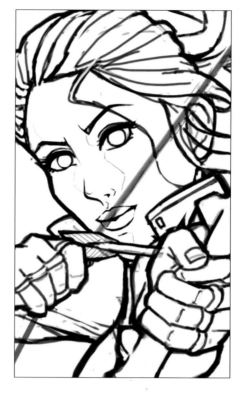

STEP 4

Next, begin to refine and add details, zooming in and out as needed. I paid a little more attention to my character's face, as it's such an important part of the design, and decided to move her head up slightly so it's not obscured by the bow.

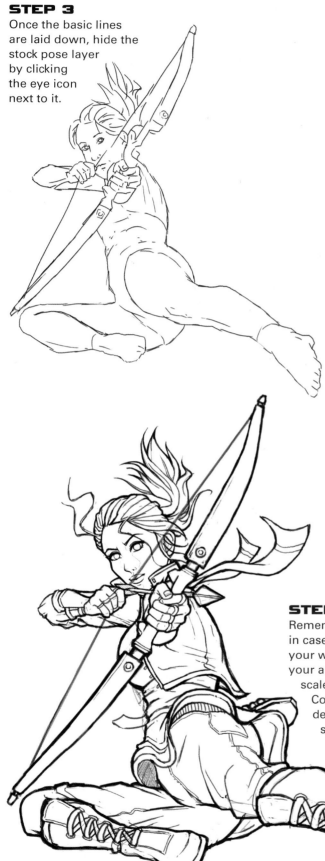

STEP 5

Remember to save throughout the process, in case you have a computer crash. Save your work as a PSD file. If you want to post your artwork on the web later, it can be scaled down and saved in a JPEG format. Continue to tweak and add clothing details to the rest of the image until the sketch is complete. This one would be well suited to a fantasy RPG-style game or story.

DIGITAL INKING

To bring line work to the next level, you can ink the artwork digitally. This can be done using various methods, but the end result is to make the lines look clean and crisp like a comic page or suitable for print without the stray lines, wobbles and smudges you get from simply sketching. For this example I've sketched a scarred samurai – the kind of lone ronin you might find featured in samurai or martial arts manga. You can work from a digitally created sketch as before, or from a scanned drawing (see pages 52–3).

STEP 1

Set up the canvas and layers as usual, then create a clean layer to add the inked lines to. The scanned sketch layer is underneath. Convert the grey pencil lines to blue. To do this, go to Image –> Adjustments –> Hue/Saturation (I have this shortcut customized to Ctrl+H/Cmd+H), then check the Colorize box before moving the colour slider to blue. You could also drop the sketch layer to a lower opacity, such as 50%, to fade out the sketch so that it will interfere even less with the inking process. Give the sketch layer a 'Lock All' lock to prevent accidentally drawing on it. Create a white background fill layer at the bottom of the Layers palette, also with a 'Lock All'.

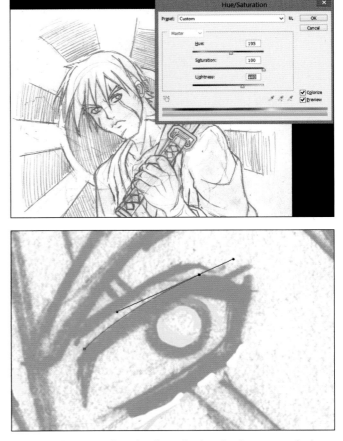

STEP 2

The Pen tool is used as though you are creating a dot-to-dot picture by placing anchor points around or along lines, which create paths. These paths can then be filled, resulting in digitally perfect lines. It's a tricky tool to get used to, so don't expect things to go smoothly at first. Zoom in to the image – it's essential to work on a large scale for best results. Select the Pen tool, then via the tool options bar set the pen to draw a path rather than a shape. Figure out where to begin – I usually start with an eye. Click the canvas to place the first anchor point (represented by a small square), then click a second time where you want the first path line to finish. Before releasing the second click, you can drag the cursor to create a slight curve.

Continue clicking around the sketchy line and adjusting the curves until you end up back at the beginning, completing and closing the path. There will be a small circle next to the pen cursor to show you are completing the path. To edit nodes and curves created with the Pen tool, hold down Ctrl/Cmd, select an anchor point, then drag to move the anchor point location or click one of the curve points to adjust the curve. Hold the Alt/Opt key and select an anchor point to edit individual curve points.

STEP 3

With the Lines layer selected, right click the path and select Fill Path. I'll fill it with my black foreground colour. I can now remove the path by pressing delete, leaving nice crisp lines.

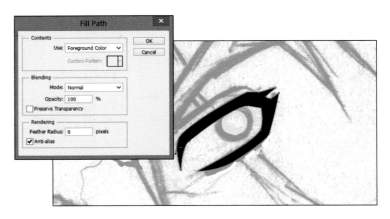

STEP 4

For the eyelid, I just want to draw a single line, rather than fill in an area. First I need to set up my Brush tool to a hard, 5-pixel diameter. Go back to the Pen tool, right click the eyelid path and select Stroke Path. Then choose Brush from the drop-down menu. If you want, you can check the Simulate Pressure box, which will taper the ends of the line. You can adjust the amount of tapering beforehand via the Brush setting menu.

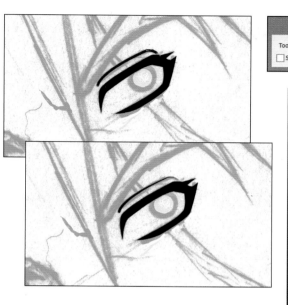

STEP 5

For circles such as the iris of the eye, I sometimes use the Elliptical Marquee tool. Draw a circle selection at the appropriate size, then right click in the selection and choose Stroke. Stroking Inside a selection often yields better results than Center and Outside.

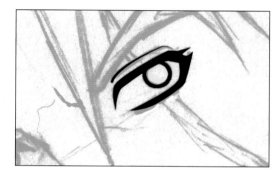

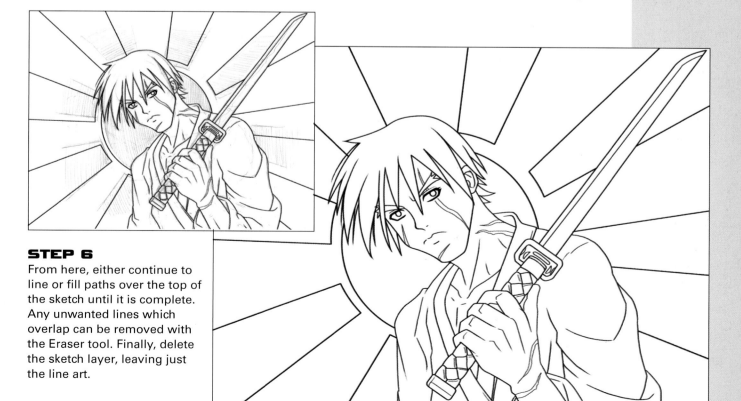

STEP 6

From here, either continue to line or fill paths over the top of the sketch until it is complete. Any unwanted lines which overlap can be removed with the Eraser tool. Finally, delete the sketch layer, leaving just the line art.

CHAPTER 3
SCANNING, ADDING COLOUR AND CEL SHADING

If you want to mix your traditional pencil or ink work with Photoshop, no problem! This chapter delivers comprehensive instructions on how to scan your character drawings and clean them up. If you like working with a lot of black-and-white drawings or manga pages, digitizing these works and optimizing their quality is an important step to learn. The next stage will cover the all-important addition of colour and working with an anime cel style.

Chapter highlights

▲ Scanning artwork

▲ Cleaning up a scanned image

▲ Laying flat colour tones

▲ Creating an animation cel look

▲ Skin shading

▲ Hair shading

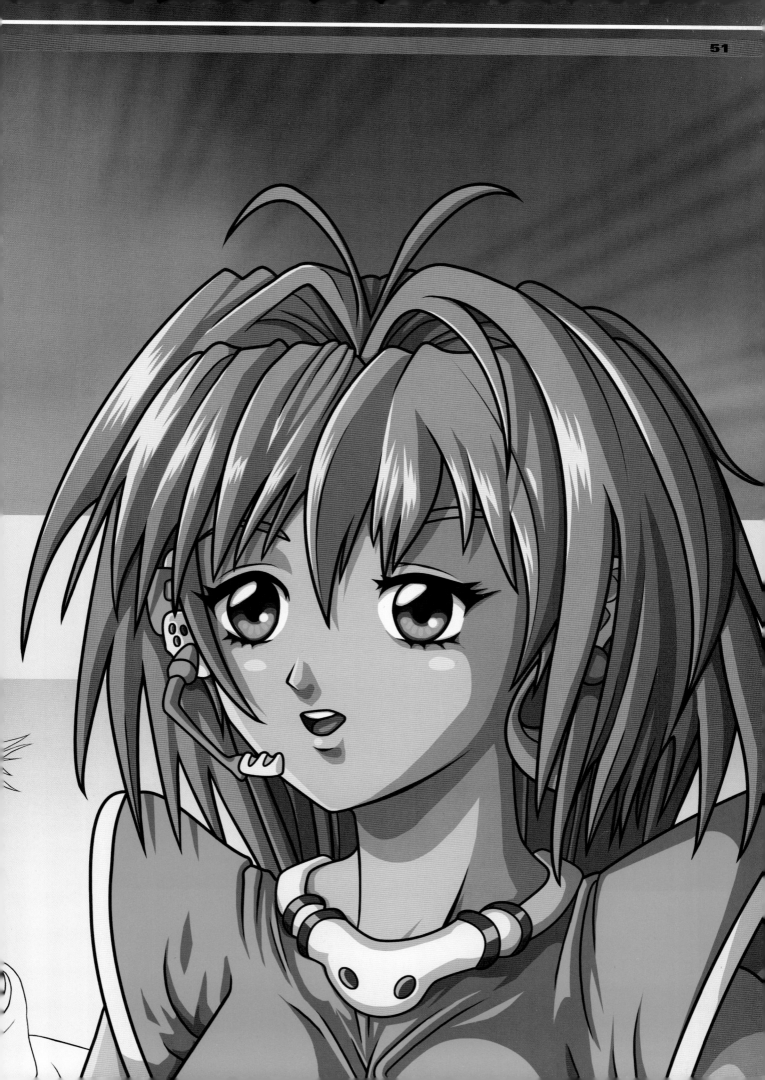

SCANNING

It's important to be able to transfer traditional artwork into a digital format on the computer without losing any of the original quality – or, even better, to make the scan improve on the original! It's good to know how to enhance your images to make them look cleaner and sharper than your original artwork, especially if you intend to colour your work. For the example here I have used an inexpensive A4 Canon scanner.

STEP 1

After you have placed your artwork in your scanner, open up the 32-bit version of Photoshop to allow use of the TWAIN scanning interface. The 64-bit version can also be used, although it only supports scanning technology and interfaces such as WIA and ImageKit. A 64-bit Photoshop TWAIN plug-in is available via the Adobe website, however.

Go to File –> Import –> (your scanner name). A scanning menu or window appears. From here you should be able to perform a 'prescan', or scan preview. Once the prescan process is complete, the preview display on the left indicates how the scanner will translate the drawing or artwork once it is in Photoshop.

There are a few things you can do next to get better scan results. First, set the scan resolution option to 300 dpi, which should always be the minimum when scanning artwork. This will produce a high-resolution scan which will be easier to colour and work on later, and you can always downsize your image if you intend to publish it on the web or email it to friends. The exception is if you intend just to quickly scan a rough sketch, perhaps to put on the web or to email, in which case 72 dpi would be fine. If your computer has a low amount of RAM, try scanning at lower resolutions to avoid Photoshop crashing.

STEP 2

Use the cursor to draw a selection box around the image. This means that only what's inside the box will be scanned, saving on scanning time (see dotted lines on image). If you're scanning a sketch in pencil or black ink, confirm that the output type or Color Mode is set to Grayscale and not B/W (black and white), Color or RGB /CMYK (color). The problem with B/W is that the scanned lines are black and white pixels only, and the lines are not anti-aliased (which means they come out jagged and pixelly). If the scanner is set to one of the colour options it will pick up unnecessary colours, when all you want is the grey/black line art.

You can adjust various Image Settings, which might include Auto Tone, Unsharp Mask, Grain Correction, Contrast and Exposure. It takes a little trial and error to establish the best settings for your scanner, so try out several options to see how your artwork looks. At this stage, I like to get a slightly higher-contrast scan to make my pencil art look clean, dark and defined, although after importing a scan into Photoshop there's plenty of opportunity to readjust contrast settings.

If you're scanning from a sketchbook, make sure that the scanner lid is firmly down, since the closer the image is to the scanner's glass, the more detail will be picked up. It's a good idea to leave a heavy weight on top while the scan is underway, so there's always an even pressure being applied – if you hold down the lid with an unsteady hand the scanned lines may come out looking crooked. If the scanner lid isn't shut, light can sometimes get in and reflect on to the image, which further reduces the scan quality. Finally, click 'Scan' to scan the image into Photoshop.

CLEANING UP THE SCAN

After scanning your artwork into Photoshop, you'll need to make adjustments to improve the scan before you start working on the image.

STEP 1

The first thing to do is to adjust the levels: Image –> Adjust –> Levels [Ctrl+L / Cmd+L]. Spend a bit of time tweaking the tonal range until the lines look nice and dark. For this image I selected Input Levels 129 for dark tones, 0.74 for mid-tones, and 246 for light tones. If you're not too fussed about giving your artwork a full clean up as described here, just increase the light tone value until the lightest areas become pure white; this way you'll end up with a clean black-and-white sketch. If you've just scanned in some pencil work, you might prefer the look of really dark lines or you might like to keep it lighter like the original. I usually go for something twice as dark as my original sketches because I usually draw with a light 2H pencil.

Instead of using Levels, you might want to try Brightness and Contrast: Image –> Adjust –> Brightness. I have assigned the shortcut key Ctrl+B / Cmd+B for the Brightness and Contrast menu, since I use this type of adjustment a lot.

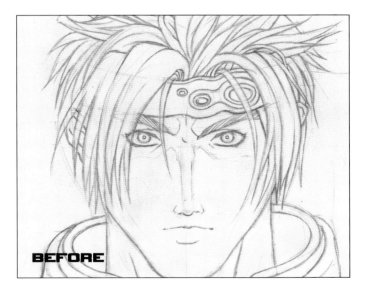

BEFORE

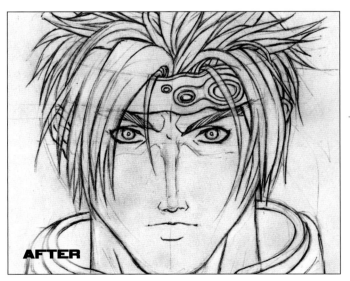

AFTER

It's very important to prepare the image in the correct way, whether you want to colour it later or not. I've seen so many pictures that could have looked twice as good if only people had bothered to spend a little time cleaning them up and making the lines sharper.

STEP 2

A scanned image doesn't always appear completely straight, so you might need to adjust and rotate the canvas slightly. I advise adjusting the canvas size of your image, making it slightly bigger round the edges by 100 pixels or so. Then go to Image –> Rotate canvas –> Arbitrary and rotate CW (clockwise) or CCW (counter-clockwise) from 0.5 degrees to 5 degrees, or however much you need to get the image lined up perfectly. Next, crop the image, using the Crop tool. It's always a good idea to crop a picture right down if there's a lot of unnecessary blank space around the image, as this reduces the file size.

Rotate Canvas ✕

Angle: 0.5 ● °CW OK
 ○ °CCW Cancel

STEP 3

If certain parts of the scan are lighter than others, you can darken lighter lines by using the Burn tool or the Airbrush tool set on Colour Burn at 10% pressure. This is a subtle change, but it helps to make all your pencil lines look more consistent.

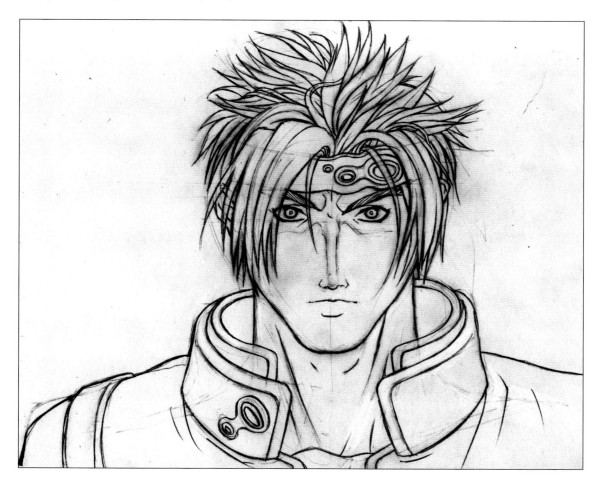

There will probably be a few smudges and random, dark unwanted pixels, dirt or scum on the image. To remove these, use the Pencil or Paintbrush tool and colour white over these areas. To clean up small nooks and crannies, try using the Polygon Lasso tool, then simply fill in the selection that needs to be cleaned with white, or just click Delete, making sure white is your secondary colour.

STEP 4

If done properly, fully cleaning up the image can take some time. Being a perfectionist, I always try to clean up images really well. The best way to do this is to zoom in on the image, then use the Polygon Lasso tool to go round each line on the picture to neaten it up. You won't know the mess is there unless you zoom in on every bit of the image; needless to say, this process can be very time-consuming!

After you have made a selection using the Polygon Lasso tool, you can make additional selections by holding the

Shift key (the cursor icon will change to a + sign). To subtract from part of your existing selection, hold the Alt / Opt key. It's not necessary to keep these keys held down while creating selections, just use them to add or subtract when starting a new selection.

If you are going to use the image on the web or as a very small print, it's not necessary to aim for perfection so you may choose to bypass this step. But as this particular image was needed for a large print, it was a good idea to make it as tidy as possible.

BEFORE

AFTER

STEP 5

If you want to save your image as it is and put it up on the web without colouring in the line work, then adjust the image size: Image –> Image size (Cmd+Alt+I). You'll possibly want no more than a pixel width of 800 pixels, but that depends on whether your image has a lot of detail or not. You'll have to be the judge of what image size looks best for your particular picture – have a look on other artwork sites and see what sizes are used. You can do this by right-clicking the full-sized image and selecting Properties or View Image Info from your web browser. Once your artwork is resized, it can be saved as a jpeg.

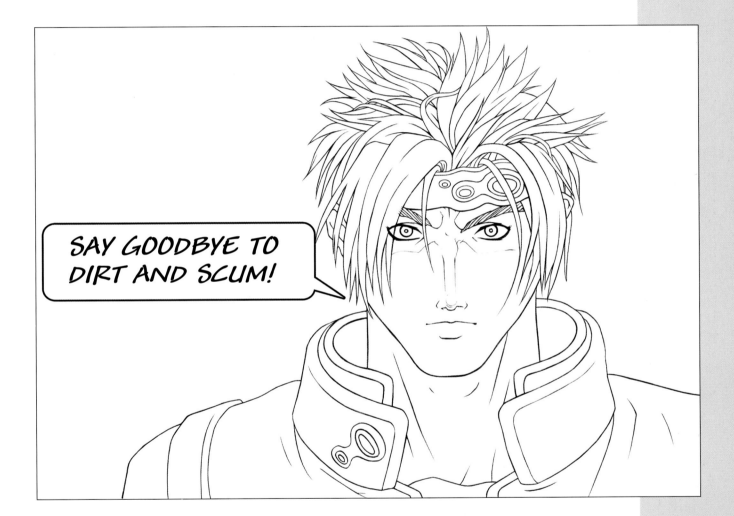

STEP 6

If your original artwork is larger than the size of your scanner surface, you will need to scan it in sections and join them up in Photoshop. For example, if you have scanned an A3-sized picture with your A4 scanner in two separate sections, first adjust the canvas size (Image –> Canvas size) of the scan #1 to a little over double and make sure you have white selected as the secondary colour.

Now go back to scan #2, select the layer 'Background' in the Layers panel and copy or drag this layer on top of scan #1. Use the Drag tool to move scan #2 so that it fits in perfectly (or nearly) next to scan #1. A good tip for adjusting the scan #2 position is to zoom in at 100% and get the lines flush with scan #1.

If the lines simply refuse to join up properly, try rotating scan #2: Edit –> Transform –> Rotate [Ctrl+T / Cmd+T]. Use trial and error to rotate the layer very lightly and see if it joins up better after the rotation. After it is lined up nicely, flatten the image (Layer –> Flatten Image) and go through the previous preparation steps.

PREPARING TO CG

If you want to colour your scanned line work digitally, there are many ways to do it. In this section I'll explain the two most common methods. The first, the channels method, is the one I prefer because it allows me to isolate the line work and colour and edit it later on.

Method 1

STEP 1

When working with a new canvas, scan or flattened image, you'll notice a single locked layer, named 'Background', in the Layers palette. To make this editable, double-click 'Background' to bring up the New Layer dialogue box. Rename the layer 'Line Art' and click OK. Alternatively, to quickly unlock the 'Background' layer and make it editable without renaming it, hold Alt / Opt and double-click the layer.

STEP 2

Go to the Channels panel and click the circular channel selection icon at the bottom. The image lines should be filled with dotted selection lines.

Next press the delete key – this will get rid of all white areas. You will have a grey checked background which shows the image is now transparent.

The check colours can be changed in the Photoshop preference settings: Edit –> Preferences –> Transparency & Gamut [Ctrl+K/Cmd+K]. I generally use light grey and dark grey squares, so if there is any unwanted white on my layer it'll be easier to spot.

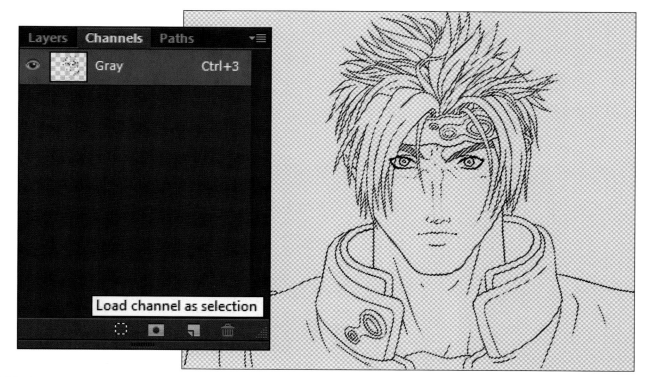

STEP 3

As Step 2 has taken some of the black from the line art, this needs to be reapplied. Deselect the channel selection, then move back to the Layers panel and check the Lock Transparent Pixels box. Use the Pencil tool with a large brush size (5000 pixels is the max) and cover the whole picture to restore black to the outlines. I find it easier to use a black to transparent gradient fill. If this gradient starts from outside the canvas area it can cover the entire canvas in one hit. Now the black line work is a layer on its own, similar to the outline of a typical animation cel.

STEP 4

Adjust the image mode from Grayscale to Color: Image –> Mode –> RGB. Create a new layer underneath the line art layer called 'BG' or 'Background', fill this layer with a white solid fill and check the Lock All box.

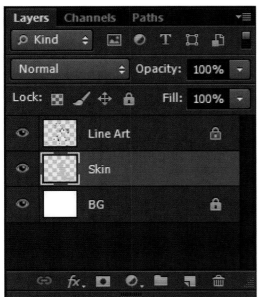

Layers tab: channels method

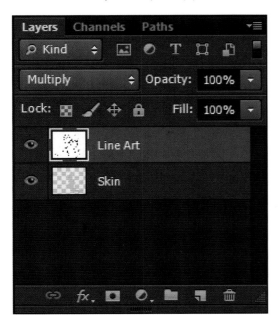

Layers tab: multiply method

STEP 5

Create a new layer above Background white and beneath Line Art, and call it 'Skin'. The image below shows how the Brush tool can be used to add colour without affecting the Line Art layer.

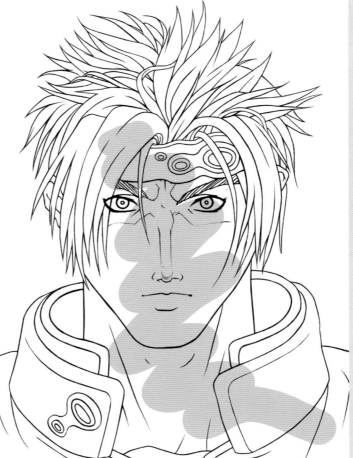

Method 2

STEP 1

In the Layers panel, make the Background layer editable and rename it 'Line Art'. Adjust the image mode from Grayscale to Color: Image –> Mode –> RGB.

STEP 2

With the Line Art layer selected, go to the Layer Blending Mode drop-down menu and select Multiply. This will allow all white areas to be viewed as transparent. Create a layer underneath the Line Art layer called 'Skin' (layers can be placed by dragging and dropping on the Layers panel). Start to paint in the skin and you'll see the colour is visible underneath the Line Art layer.

LAYING FLATS

So you've seen how I have scanned in my image and optimized it, ready for CGing. The next step is to add colours to all parts of the picture.

I often work on a different layer for each colour or tone, so the skin colour is on one layer named 'Skin', the hair colour is on another layer named 'Hair', and so on. However, I do sometimes use the same layer for different colours, for example, eye and mouth colours will be placed on the same layer named 'Eyes Mouth'. The advantage of using the same layer for more than one colour is that file sizes are smaller so Photoshop will use up less of your computer's RAM. Also, having fewer layers to sift through within the Layers panel will make your workflow a little more manageable. The disadvantage is that if different colours are placed on the same layer, you won't be able to adjust the eye colour without affecting the mouth colour, for example, unless you use the Wand or Lasso tools to isolate a particular area.

Instead of using multiple layers for colour and CGing to minimize file size and reduce computer processing, some people use Channels and /or selections on a single layer.

The process of laying your initial colours down is called 'flatting' or 'laying flats'. There are three ways to do this:

▲ Select the Brush tool and manually paint areas of colour onto layers

▲ Use the Polygon Lasso to select areas, then flood-fill these selections using the Paint Bucket tool

▲ Provided the line work is suitable, use the Magic Wand tool, then flood-fill the selections

Using the Brush tool to lay flats
Following on from Step 5 on page 59, continue using the Brush tool to apply a skin tone to the Skin layer, which is situated underneath the Line Art layer, until all areas are filled. You don't have to confine brush marks to within the skin areas – the aim is to be quick, without worrying about messy overlapping tone at this point.

Using the Polygon Lasso
To create a selection, start by clicking somewhere along the edge of the line art, then release your mouse button. This adds an anchor point. Move the cursor and click again to add a second point further along the line art, then release your mouse button. This draws a straight line between the two points. Continue this process to create a shape area and end the selection by clicking on your original anchor point. Use the Paint Bucket tool to fill the area within the dotted line with the primary colour selected.

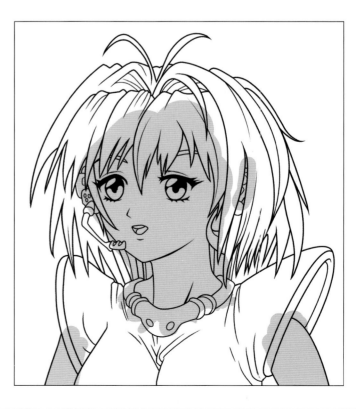

Using the Magic Wand to lay flats

If you prefer sticking to the Brush method to add the remaining colour flats, that's fine. However, as the line art in this exercise is clean, digitally inked and without gaps between areas, making use of the Magic Wand is the most efficient way to lay flats. Sometimes the Polygon Lasso Brush is also required to fill gaps that the Magic Wand can't reach.

STEP 1

With the Magic Wand tool selected and the Line Art layer highlighted in the Layers panel, click on the image in the open white space where you want to make a selection – in this case, the hair area. Hold Shift and click to select additional portions of hair. Notice the 'marching ants' that denote where the selection area is. Go to Select –> Modify –> Expand. Expand the selection by 4 pixels. This will enlarge the selection so that once a colour is added to the layer underneath, the colour fill goes all the way to the edge and slightly beyond. If you don't do this you'll be left with pixelated areas where the flat tone doesn't quite meet the line art edges.

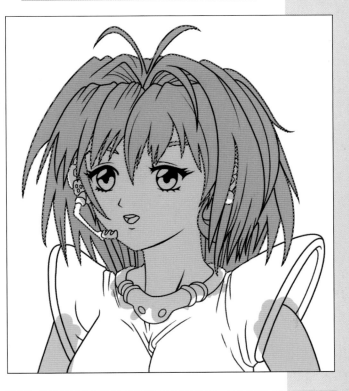

STEP 2

Create a new layer named 'Hair', and drag it above the Skin layer. This will cover up any overlapping skin tone. Laying flats like this means you can be quick and messy with the lower layers (especially if using a Brush or Lasso tool) in the knowledge that excess tone will be concealed later. Although it's not essential, I have objects furthest away on a layer at the bottom of the Layer panel and objects closer towards the top.

STEP 3

After placing all the flats on their respective layers, lock each one with the 'Lock transparent pixels' icon. This will prevent rendering outside flatted areas. Flatting can be a monotonous and repetitive process, but it's important to get solid flats laid – and once they're down you know the fun part is about to begin!

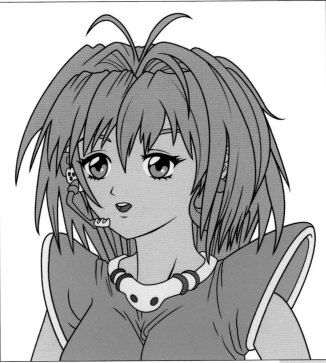

RENDERING CEL-STYLE SKIN AND HAIR

To give your work an animation and cartoon look, use solid colour tones for shadows and highlights. When placing shadows, you'll need to be aware of form and of how light falls and the shapes that are cast. Perhaps you're used to painting traditionally and are experienced in placing shadows and highlights – if not, observe from life, playing around with a lamp and camera and training both on different objects and people. Have a look at other artists' work, too, and see how they do it.

After all the relevant layers of your flats have been created and filled, take some time to consider alternative colour options for each layer. Choosing colours can be difficult, but it gets easier after experimenting with what looks good. I'll discuss colour choice more in later chapters. The good thing with digital art is that you can always change the colours or hues later on, without hassle.

Light source from top left, created in an airbrush style (below left) and then simplified to cel-style (below right)

Central light source on an embossed shape (above left) simplified to cel-style (above right)

STEP 1

Select the Skin layer (see opposite) and the Polygon Lasso tool. In addition to using Shift and Alt / Opt keys to add and subtract selections, you can use the square icons in the tool options bar (next to the Lasso icon).

Choose a darker tone for the skin shadow via the colour picker. With a left-hand light source in mind, begin to make a selection where shadows form and are cast – these will be placed on the right-hand side of the character.

STEP 2

When a selection (or multiple selections using + Lasso by pressing and holding Shift) has been created, fill with the darker tone and deselect the selection [Ctrl+D / Cmd+D]. Any areas of shadow that are too sharp or too angular can be smoothed out manually using the Brush tool with either the base or darker tone selected. You can also bypass Polygon Lasso completely and shade with a brush, if you prefer. If you do this, move the cursor quickly to avoid creating a lumpy edge where Photoshop picks up wobbles in your hand movements with the tablet pen.

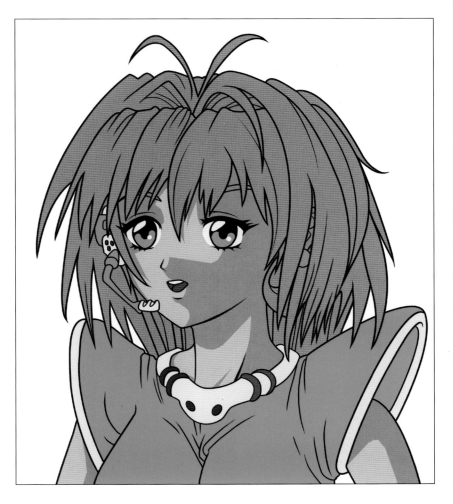

STEP 3

I felt some of the facial shadows were a bit overpowering, so I decided to trim them back. When tweaking a solid shadow tone, it is useful to have the foreground colour as your primary base tone and the background colour as the shadow tone. You can alternate between these tones by using the shortcut key 'X' on the keyboard. This makes adding or subtracting relevant tone a lot easier.

 Next, add a second selection smaller than the previous one and fill it with an even darker tone for the darkest shadows. Using a small brush, add a few small highlights of a lighter skin colour to the cheeks and nose.

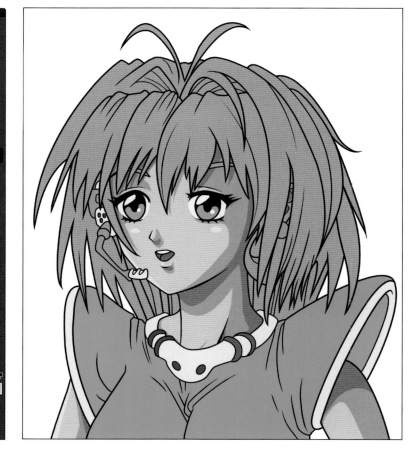

STEP 4

Moving on to the hair, use a brush with a darker tone selected to quickly plan where the shadows will be. The hair looks pretty messy at this stage, so I need to go back to the Polygon Lasso to clean up the shadowed areas. Using the Polygon Lasso makes the creation of straighter lines and sharper points a lot easier than attempting to taper lines with a brush and tablet pen. If you feel more comfortable using just the graphics tablet brush strokes or the Polygon Lasso to shade, by all means for go for it.

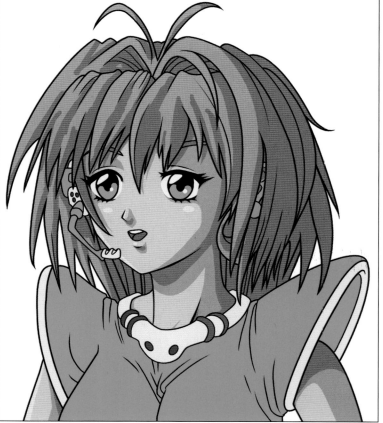

STEP 5

Add some white or lighter highlights to the hair to give some shine. Be sparing with highlights – less is more and going overboard can make an area look messy and overcrowded. As with the skin and hair tones, add shadows to the clothing and accessories.

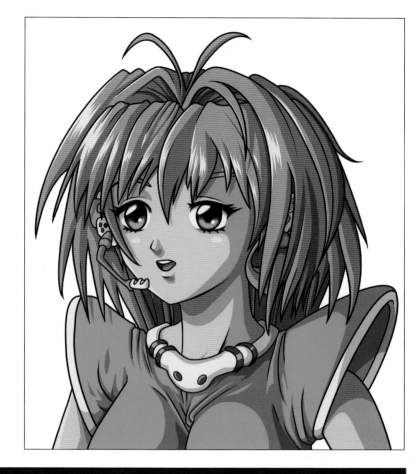

STEP 6

Neaten the image by placing a simple background round it. The lighter grey square was created using the rounded Rectangle tool and the background was kept grey so that it didn't detract from the brighter colours used on the character. Take a final look at the image and, if needed, adjust the hues on each layer. In Step 5 the skin looked a little too yellow so I adjusted it accordingly.

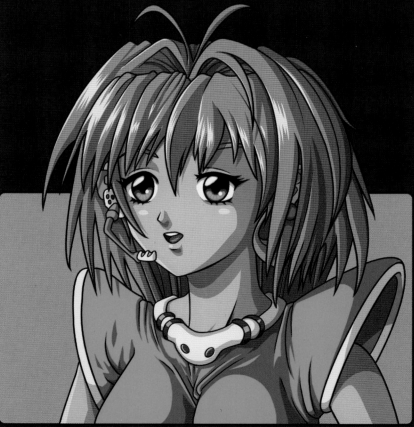

CHAPTER 4
THE SOFT CG FIGURE

The cel style used in the previous chapter looks great, especially if you're into cartoons and anime. However, there's another cool style to try, which I call the 'soft CG' look. This closely mimics the more smoothly blended shading you would expect from a traditional airbrush. The added realism and silky-smooth effects of this style can really enhance your character art.

Chapter highlights

▲ Colouring line art

▲ Creating an airbrush-style 'soft CG'

▲ Shading skin

▲ Shading hair

▲ Shading clothing

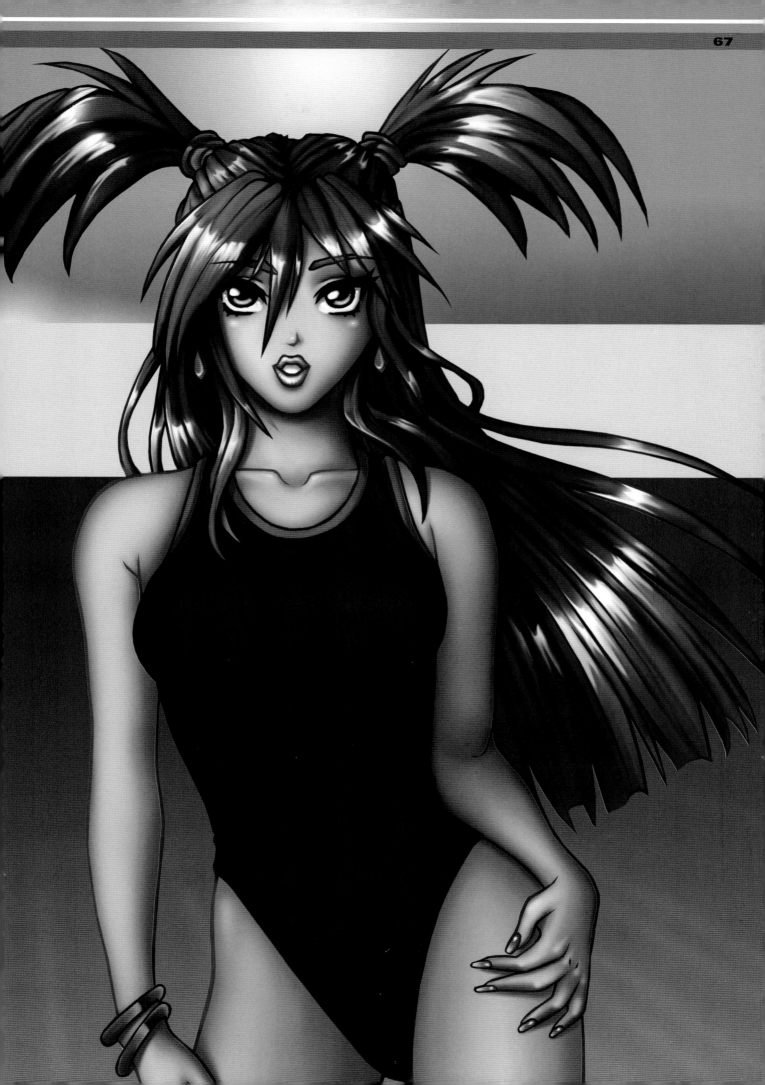

SHADING SKIN

A standing pose of manga girl Nikki is used here to illustrate the airbrush technique. This design has been kept fairly simple to allow you to concentrate primarily on rendering larger portions of skin tones and hair.

STEP 1
As with cel-style colouring (see pages 62–65), start by laying each flat colour on its own layer, labelled for future reference.

STEP 2
As with the cel-style shading, choose a skin tone a little darker and slightly more saturated for the shading. Do this by clicking the foreground colour and sampling the original skin tone via the Color Picker, then selecting a tone with a little more saturation, black and red. In this example the flat peach skin has the hexadecimal value of '#eebd8b' and my darker shading tone has the hexadecimal value of '#cf8961'.

Select the Brush tool and via the Brush options bar set it to 0% hardness. The brush size should be quite large to start with – in this case 200–600 pixels.

Whether I intend to use a standard daylight style of lighting or something little more fancy and colourful, I'll always start with a neutral range of tones which I can then adjust later on as I progress through the artwork. For example, always flat a Caucasian skin layer using a peach tone, which is a light, desaturated orange – see the Color Picker (right).

Keep the flow percentage low at between 5% and 10% to allow greater control; this creates smoother, more graduated shadows and tones. Apply an initial wave of airbrush shading around the edges of the Skin layer by using the outside edge of the brush – see the cross-hair on the image (left).

To guarantee a more uniform tone, make sure Shape Dynamics is turned off via the Brush panel (F5 on the keyboard). Turn it on if you want to control the brush size through tablet pen pressure.

STEP 3

Use the Color Picker to select an even darker skin tone and apply a second wave of shading. This is where you begin to define the off-centre light source. Throughout the process of adding shading, zoom in to the image and decrease the brush size to tackle smaller areas. In the event that a small brush has left clumps of shadow which look a little messy, increase the brush size, lower the brush flow percentage and paint over this area to blend out any unwanted marks.

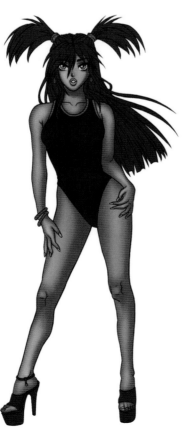

STEP 4

Using a darker brown skin colour, apply another round of shading. With this wave, try to smooth out the previous tones and add further definition. Sometimes during the colouring process, certain parts of the line art do not look quite right. In this case the shadow direction on the nose has been changed.

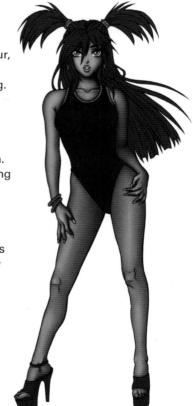

STEP 5

After building up the layers of shadow there should be a good range of tone, although here the skin looks too dark and brown and needs attention. Adjusting the brightness of the Skin layer can be done using Levels: Image –> Adjustments –> Levels [Ctrl+L / Cmd+L]. Experiment by moving the Shadows, Midtones and Highlights sliders underneath the Histogram. These are also represented by numerical values beneath.

The idea is to make the skin look natural while retaining a good range of contrast. Moving the Shadows slider too far to the right can make the skin look saturated and muddy. Moving the Midtones slider too far left can make it look washed out, and moving it too far right results in oversaturating, as with the Shadows slider. Moving the Highlights slider too far left will result in the skin tone looking overexposed. In this case, the Shadows value is set at 20, Midtones at 1.03 and Highlights at 227.

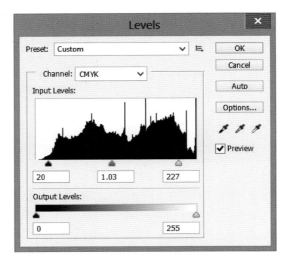

The next adjustment is Hue/Saturation: Image –> Adjustments –> Hue/Saturation. The Hue is set to –10 to make the skin a little more red/ pink and less yellow, and the Saturation is set to –25.

If the skin is still too dark or too light for your taste, make a final adjustment to the brightness: Image –> Adjustments –> Brightness/Contrast and set it to +25 or whatever value you think is necessary for maximum impact.

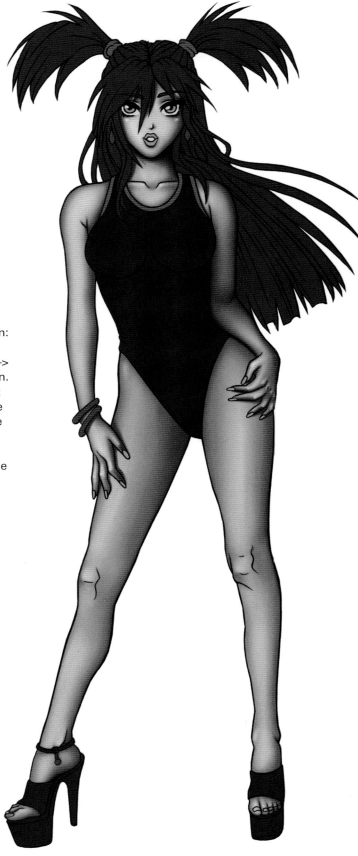

The last thing to do is to add a couple of small highlights to the cheeks. Sometimes it's also nice to add small specular (white dot) highlights to the shoulders, elbows and knees.

SHADING CLOTHING

With most of the characters I colour, I follow the same routine of methodically rendering each different colour and part of an image at a time. I start with the layer at the bottom, which is typically skin, then move on to hair, clothing, and finally to trim and details. This is just my personal preference, and you may wish to tackle different parts of the image first.

In this example, I move on to the clothing next, returning to the hair layer afterwards.

STEP 1

Select a clothing layer named 'Clothing 1'. Sometimes you may have a 'Clothing 2' or 'Clothing 3' layer, depending on the outfit, but this design is fairly simple, consisting only of a swimsuit.

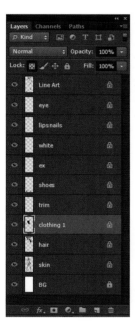

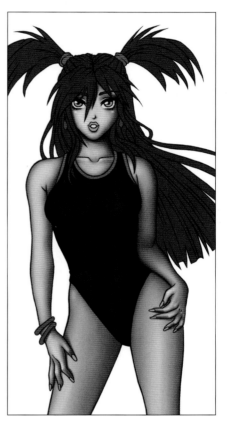

As with the skin-rendering process, select the Brush tool and set it to a large, soft, 0% hardness brush. In addition to the Brush options bar, brush sizes, hardness and other settings can be changed via the Brush panel. So far as Brush Spacing goes, keep this low – 1% spacing will create slightly straighter lines, but takes more computer power to process.

Using the Color Picker, choose a dark tone for the first wave of shading. Keep the shading primarily towards the outside edges of the swimsuit and underneath the breasts, but allow some of the darker colour to bleed onto the overall area to produce a subtle graduation of tone (above right).

STEP 2

Add a second wave of shading to the swimsuit after picking a darker tone. For any small creases or fold highlights, switch back to a lighter tone and paint these in using a smaller brush.

STEP 3

While the outlines under the breasts indicate the size and roundness, they don't need to be there, so trim these back using the Eraser tool on the Line Art layer. Remember to take off the transparent pixels lock and switch it back on again after editing the line art.

Tweak the Brightness / Contrast of the Clothing1 layer slightly, then add shading to the pink trim layer, including the bracelets and earrings.

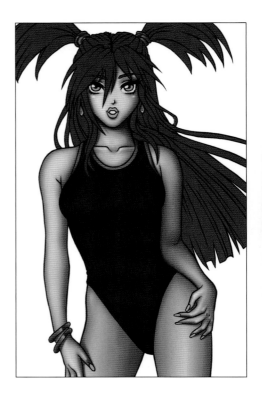

SHADING HAIR

Shiny, glossy hair can help add that extra bit of polish to make a manga character stand out. For a great effect, use white highlights and increased contrast levels.

STEP 1

Select the hair layer. As this is brown, choose a darker tone with more black for the first wave of shading. Start adding form to the fringe and ponytails. With manga style, the idea is to group portions of hair together rather than attempt to paint individual strands.

STEP 2

With yet another darker brown colour, begin to define the hair even more. It can be difficult to achieve long, smooth strokes of shadow, especially with hair and the way it bends and curls. You can use the Smudge tool to blend. On the tool options bar, try setting the Smudge strength to around 50% and adjusting it if necessary.

Also, try using the Rotate tool to angle the canvas and create a longer, continuous curve that follows the direction of your wrist movements. Aim to place the darkest tones towards the edges and alongside the outlines.

STEP 3

Roughly add in shiny highlights on the hair, using a small, harder brush.

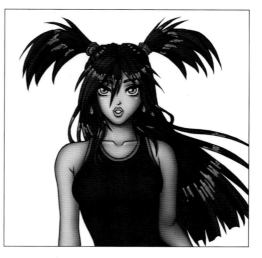

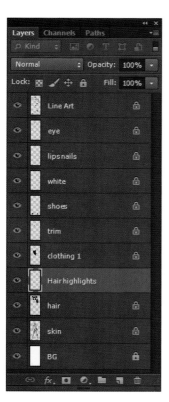

STEP 4

Use the Smudge tool to neaten the highlights so that they are smooth, blended and tapering downwards. If you're concerned about messing up the hair layer, add the highlights to a separate new layer above and refine them using the Smudge tool. Then merge this layer with the hair colour beneath. To merge, click the Layer menu icon in the top right of the Layer panel, then select Merge Down [Ctrl+E / Cmd+E]. Alternatively, right-click the layer you want to merge, then select Merge Down from the Context menu.

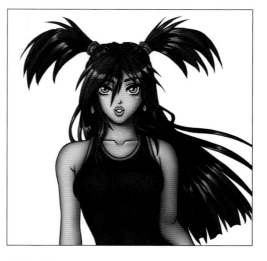

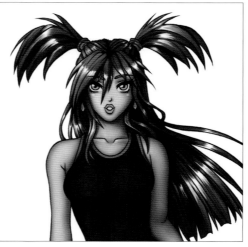

STEP 5

Adjust the hair contrast using the Levels or Brightness/Contrast adjustments to produce a high-impact glossy look. Sometimes using the Dodge and Burn tools over the top of highlights can add extra colour variation and style.

FINISHING OFF

Using the techniques you have learned so far in this chapter, put the finishing touches to your character.

STEP 1

Shade the shoes using darker tones. Create a new layer above the Shoes layer and name it 'Shine'. With the Shine layer selected, add a white highlight to the shoes to create a gloss effect. The reason for doing this on a new layer is that the layer opacity can be adjusted and toned down if the white is a little too strong. In this case, the opacity of the Shine layer has been reduced to 65% via the Layers panel.

STEP 2

Zoom right in to shade the lips and nails. Sometimes you might decide not to match these and to colour the lips a different hue. As they are both on the same layer, it's possible to isolate the lips by using the Lasso tool to create a selection around them. Then tweak Hue or Contrast.

STEP 3

Next, shade the whites of the eyes and teeth. I always use a grey or off-white for these. Then colour the irises. With green eyes, I usually add a lime or yellow highlight towards the bottom of the iris and keep the top part of the iris dark to blend into the upper eyelashes and add more contrast against the white eye highlights.

STEP 4

Now colour the line art. With the Line Art layer selected and the transparent pixels locked, use a brush to paint on to the lines themselves. Rather than keeping the line art black, this helps to merge the lines and colours into a cohesive image. Use different colours for different parts of the image – for example, a dark brown around the skin and a dark purple around the pinks. It's a subtle effect, but softens the overall artwork and looks great.

Layer shading summary

▲ Lay flat colour

▲ Apply a wave of shading using a soft, large brush

▲ Apply more waves of shading with increasingly darker tones and smaller brushes for details

▲ Adjust contrast levels if necessary

Alternative versions

There are infinite variations and techniques you can use to give artwork a different look and style. Here are a couple of alternatives for the same line art, one of which uses a higher-contrast, over-exposed range of values while the other is lower contrast, with a warmer tone to it.

CHAPTER 5
COLOUR CHOICE

There is more to adding colour and rendering than just the placement of tones and hues. Colour can represent a character's emotions, personality and preferences. Also, with digital artwork, there are always issues with getting your colours to look the way you want for web or print. This chapter demonstrates how to deal with these problems.

Chapter highlights

▲ Colour theory: planning colours, lighting, and colour choice

▲ Colour examples

▲ Technical colour issues: screen vs print

PLANNING COLOURS AND LIGHTING

Many artists learn which colours work best together through practice, observing other artists' creations as well as the world around them. However, there is also a science to making an attractive piece of artwork.

Understanding the relationships between colours can save you years of trial and error attempting to make your art look effective.

Colours are described in the following terms:

▲ A hue is a colour in its purest form, with no black, grey or white added
▲ Value or lightness is determined by the amount of black or white in a hue
▲ Saturation describes the intensity or dullness of a hue
▲ Shades are mixtures of a hue and black
▲ Tints are mixtures of a hue and white
▲ Tones are mixtures of a hue and its complement or greys

Primary colours
Red, blue and yellow are described as primary colours because they cannot be created by mixing other colours. However, all other colours are produced by mixing primary colours in various combinations. In digital terms, mixing paint is a case of interlacing coloured pixels at different percentages.

Secondary colours
The secondary colours – green, purple and orange – are created by mixing two primary colours. Yellow + blue = green, blue + red = purple, and red + yellow = orange. The secondary colours can be seen on the wheel below, between the primary colours used to mixed them.

Tertiary colours

A tertiary colour is produced by mixing a primary colour with a secondary colour, for example, yellow + orange, red + orange, red + purple, blue + purple, blue + green and yellow + green.

Balance

For a striking, successful artwork you need to use a focused colour palette, while balancing the piece by varying the colour intensities throughout. An unsuccessful work might use primary colours only or too many colours (the latter creates a confusing, busy image). Decreasing the vibrancies and saturation of certain elements can help to make other parts of the image stand out, drawing attention to more important features or creating a sense of continuity.

Complementary colours

These are hues opposite each other on the colour wheel, for example, red and green, blue and orange or purple and yellow. Using such schemes can be tricky, but they provide the highest colour contrast. Stick with a dominant main colour such as blue, then use orange for smaller touches or as a secondary light source for maximum effect.

Relevance

When choosing a colour scheme, make sure it's relevant to the mood of the piece you're creating. For character art, perhaps consider using lots of dark reds and black for a villain and whites and blues for a hero. Pale tones could be used for a modest, quiet character, while more vibrant, bright colours can indicate someone more outgoing who likes to make a statement with their outfit. If, for example, you are designing an Amazonian warrior, use browns, greens and natural tones – a warrior such as this might not have access to, say, a bright red velvet cape, and it wouldn't be much use when trying to make a surprise attack on the enemy!

Contrast
This isn't just the difference between light and dark, but includes warm and cool and sharp and soft. The most effective images often succeed by maximizing contrast. Here is a comparison between high- and low-contrast treatments of the same image using Cybernetik girl and a stock photo background provided by Malleni-Stock.

I've used various techniques to increase contrast:
▲ More colour saturation
▲ Increased values between the lights and darks
▲ A peachy-orange skin tone which complements the outfit's blue tones
▲ Blurring of the background to focus on the character details
▲ Warm tones in the background on the right to complement the blue wires on the left

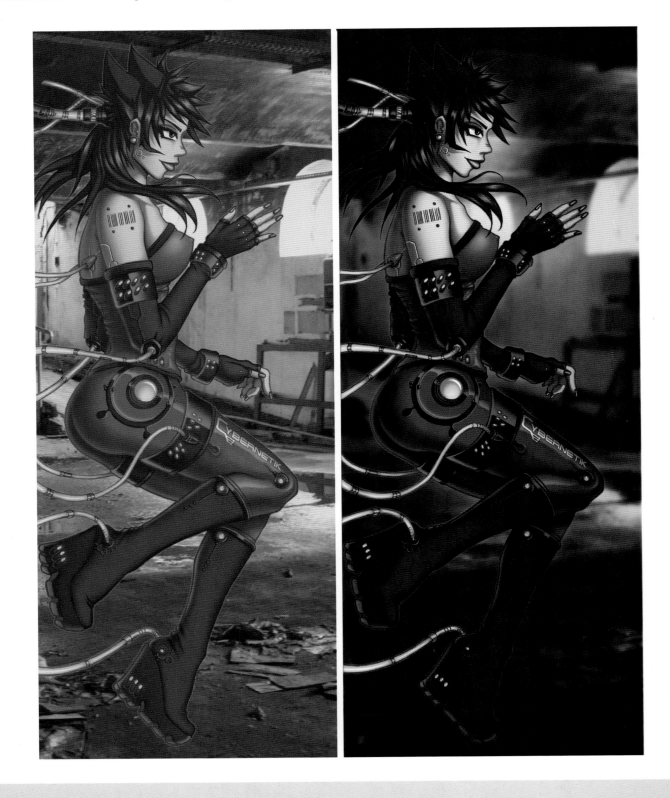

Monochrome

Sometimes hues can get in the way of understanding the power of values and contrast. Experiment working with just black, white and greys. In order to create maximum impact, it's important to use a full range of lights and darks.

The influence of light

Different types of lighting affect the colours of objects. It's rare for a white piece of cloth to be pure white, for example. If it is placed outside on an overcast day, it'll appear more grey, while inside, under a lightbulb, it'll have a yellow or orange tinge to it. While I usually start my artwork using a natural base tone, I always end up adjusting hues and variations in colour to make a character's tones relative to its environment.

Focus

Make the focal point – the area you most want to draw the viewer's attention to – the lightest and brightest part of an image. With a figure, this might be the eyes or a magical weapon, for example. If you are adding a background, keep the character as bright as possible, while dulling down the scenery around it.

Colour palette

This is a term used to describe the collection of colours used in your image. In Photoshop you can create a palette based on your work so far, if you wish to make sure of limiting your colour range and maintaining continuity.

 Convert your image to index colour: Image –> Mode –> Indexed Color. Set the amount of colours you want within your swatch (256 is sufficient) and click OK. Then click Image –> Mode –> Color Table. From here you can click to save the palette as an ACT file. Go to the Swatches table and click the Menu icon towards the top right. Choose 'Replace Swatches' and locate your previously saved ACT file – make sure the ACT file type is selected via the drop-down option so that it shows the 'CLUT' icon in your browser. Also remember to 'Undo' to revert your image to RGB or CMYK from Indexed colour.

COLOUR EXAMPLES

While it might be tempting to go wild with a huge variety of colours, it's generally preferable to limit your palette and use a colour scheme. This is often how the most effective stand-alone pieces of character artwork are created. For optimum results use colours adjacent to each other on the colour wheel (known as analogous colours).

These sci-fi character artworks demonstrate the use of different colour schemes. 'Bengosha' (below) illustrates the use of blue tones with an orange secondary colour, while 'Elise' (opposite) uses analogous pinks and purples.

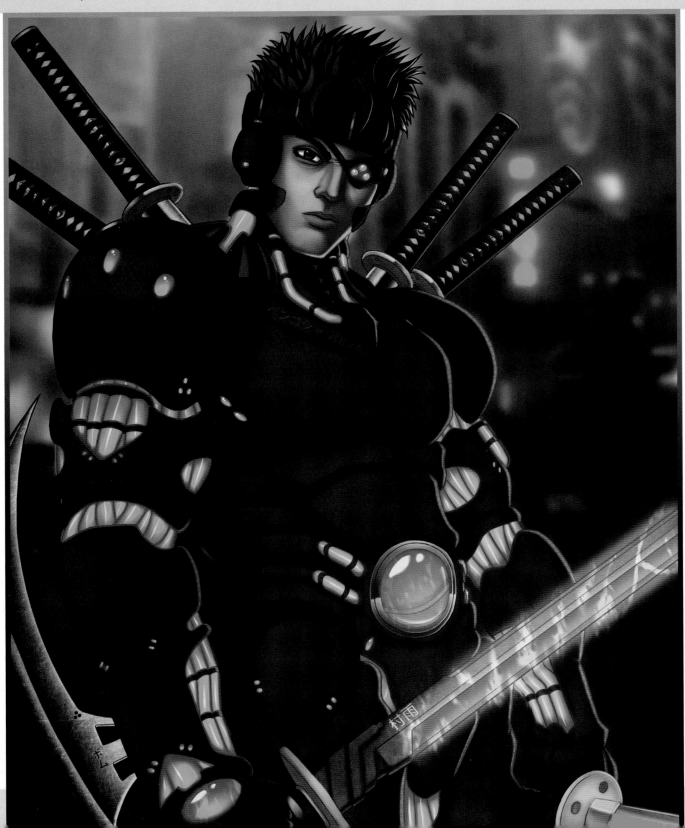

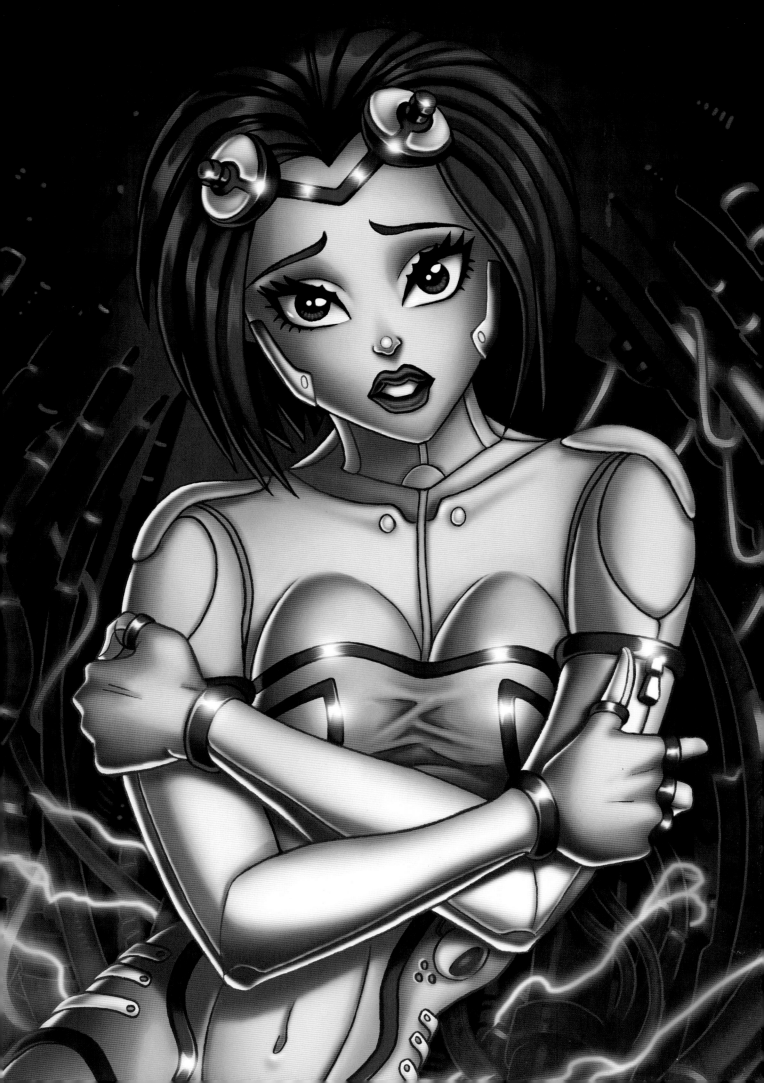

TECHNICAL COLOUR ISSUES: SCREEN VS PRINT

The specifics of colour modes and technical printing issues aren't straightforward at the best of times, and the many artists I've spoken to over the years have different opinions on how to set up their work and optimize it for print- and screen-based media.

Colour settings

RGB stands for Red, Green, Blue. It's a colour scheme associated with electronic displays such as LCD monitors, cameras and scanners and it works by combining these three colours to produce a range of hues and tones. RGB is an additive colour model – colours come from a source that emits light (the screen) and light colours can be mixed together until white light is created. When all three colours are combined and displayed to their full extent, the result is a pure white. When all three colours are combined to the lowest degree, or value, the result is black. RGB offers the widest range of colours, allowing vivid hues like lime green and turquoise really to pop.

CMYK is a process used for printers. It stands for Cyan, Magenta, Yellow and Black. Using these colours in various amounts creates all the necessary hues and tones when printing images. CMYK is a subtractive colour model – the colours come from inks (or paints or dyes) that are overlaid until they shut out wavelengths of light and produce different colours. A CMYK file is larger than an RGB file because it has four colour channels (referred to as 'plates' in lithographic printing).

Setting up an artwork canvas as CMYK means that the colours seen on screen match more closely with a print. This can help to avoid potential pitfalls if you are trying to convert from one colour mode to the other. Such pitfalls include the need to substitute RGB-only colours to work within a CMYK colour range. However, I have worked with print companies who are able to colour match from an RGB file and the end result is better. Also, if you are likely to be working on digital comics, books, games, animation or film artwork you might be better off sticking with RGB. This will give you the benefit of vivid RGB colours and the ability to use extra filters and image adjustments in Photoshop; you can then convert to CMYK, if necessary.

Converting RGB images to CMYK

Converting modes to make a print can be a complex task. Occasionally RGB images contain colours that are 'out of gamut', which means they contain colours that the CMYK colour mode cannot reproduce. To check for this, click View –> Gamut Warning [Ctrl+Shift+Y / Cmd+Shift+Y]. Colours that turn grey are incompatible with CMYK mode. Photoshop can replace these colours with what it calculates as the next best colour, or you can manually use the colour replace tool to select the closest matching colour and Preview the CMYK mode via View –> Proof Colors.

After converting your RBG artwork using Image –> Mode –> CMYK, it can be saved immediately or you can tweak adjustments such as Levels and Hue/Saturation to shift your colours closer towards the original tones. However, I find that most of the time the conversion from one colour mode to the other is barely noticeable.

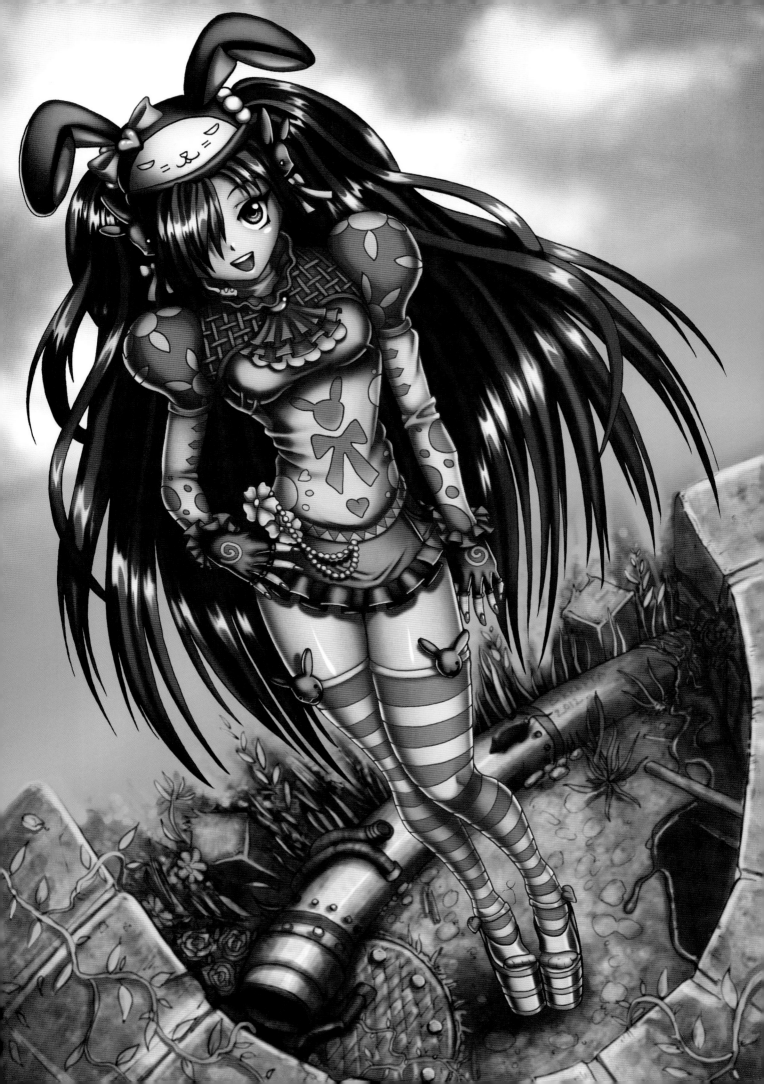

CHAPTER 6
FROM A FANTASY WORLD

Every character you create can require a slightly different approach, possibly with a range of techniques. The first character in the line-up here is Japanese warrior girl Yuki. I will use her as a demonstration tool to show ways in which you can make skin look more interesting. You will also find out how to create two-tone hair colours and add a patterned material overlay while retaining the shaded areas beneath for a seamless, three-dimensional look.

Mini-tutorials
▲ Soft CG colouring
▲ Enhancing skin tones
▲ Enhancing hair colours
▲ Pattern overlays

Rendering style
▲ Soft CG

Internet
▲ Tutorial video and materials download:
 http://digitalmanga.organicmetal.co.uk

CHARACTER RENDERING

The great thing about working digitally is the ability to add overlays, patterns and textures to artwork easily and quickly, without painstakingly drawing them in manually. I want to give this artwork a soft, airbrush feel, as with the full-figure tutorial on pages 68–75. I've experimented with different rendering methods for this style in the past, such as the subtle 'low flow' build up of tone as explained with the full figure. Sometimes I'll start with what looks like solid cel-style shadows and then soften out the shadowed edges later. This can help me plan my light source and figure out what shadows will be cast, so that my shading looks solid and bold rather than tentative and subtle.

STEP 1

The first stage is to create the Line Art layer. I wanted Yuki to be a Japanese-inspired demon hunter warrior with a fantasy twist and a kimono-style outfit. I then inked the artwork digitally (see pages 48–9).

STEP 2

I laid the flat tones (see pages 60–61), and Yuki was ready to colour. At this stage, don't be overly concerned about colour choice and whether colours do or don't share a theme. You can start shading and then alter the colours a little later on.

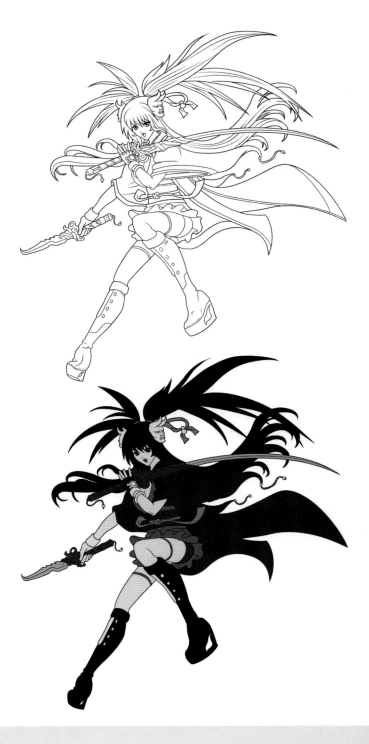

STEP 3

I blocked in a first pass of shadows using a hard brush for each individual layer. I chose a centre-right light source, so my shading would mostly be placed towards the left.

STEP 4

With a soft, low-flow percentage brush, I softened the image and blended in some smooth shading. As with the full-figure tutorial, I started with the skin, increasing vibrancy and contrast using the Levels or Brightness/Contrast

adjustments. The skin's colour value at this stage can look a little one-dimensional. Adding a secondary light source and shadow conditioning (with additional tone or desaturated shadows and shaded areas) can help make things look deeper, more realistic and more dynamic.

With warm tones such as skin, I like to add a colder grey, blue or purple shadow colour or secondary light. This can be done now, but I prefer to leave it until I'm happy with how the natural skin shading looks. There are a couple of ways to add additional colour values, secondary lighting and shadow conditioning.

When you are experimenting with lighting, I suggest duplicating the Skin layer. Then, if you make any irreversible mistakes and use up all your History states, delete this duplicate layer and start again on the Skin layer copy.

STEP 5

For a manual secondary light method, select a blue, purple or grey tone via the Color Picker and set up a larger, soft, low-flow brush, setting its mode to 'Color'. Note that this is the brush-blending mode, not the layer-blending mode. 'Screen' and other brush modes can also yield effective results, so give them a try some time. Use the brush as with regular shading on the darkest parts of the skin, towards the left-hand side edges and shadowed areas.

If this newly laid blue tone is too overpowering, it can be lightened and blended in with the skin by simply lowering the opacity of this duplicate Skin layer with the unedited Skin layer showing beneath. Also, if you've gone too heavy with the blue tone, the Eraser tool can be used on this layer once transparent pixels have been unlocked.

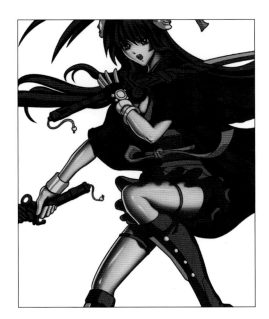

STEP 6

Alternatively, to replace shadow colour, go to Image –> Adjustments –> Replace Color. Use the eye dropper to select the darkest brown colour on the skin layer. Adjust the fuzziness to your liking; this affects the tolerance and spread of the colour to be replaced. Then adjust the Hue, Saturation and Lightness sliders accordingly. It's possible to create some really dramatic effects this way with ease. However, I'm going for something more subtle with this picture.

 Once the skin lighting or shadow colours are changed, the duplicate Skin layer can be merged down on to the Skin layer, or left on its own layer in case you want to go back to it later.

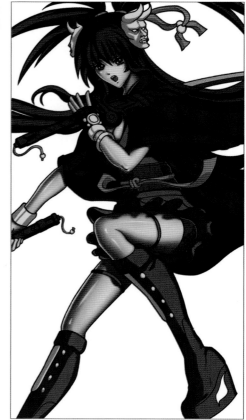

STEP 7

On the Hair layer, set a large, soft, low-flow brush mode to Multiply. This will darken existing shades on that layer and multiply the amount of dark on the base tones. Use this brush to give form to the hair by shading towards the ends and edges. Use the [and] keys to move up and down with your brush sizes to help reach narrower sections of hair.

STEP 8

Further refine the hair using a smaller, lighter brush with a normal blending mode. The Smudge tool can be used to taper out clumpy rendering and brush strokes. When adding highlights, it's a good idea to create a new, separate layer above the hair as you can edit this independently without affecting the surrounding hair shading. Use a hard white brush to rough out where you'll be adding areas of shine.

STEP 9

Now use a combination of the Smudge tool and
Eraser to sculpt the highlights into more defined
shapes. Sometimes I leave the highlights as they
are and move on to the next layer of shading. In
this instance, I faded them out by adjusting the
layer's opacity to 60%. Merge the highlights and
hair layer, then use a brush set to Color Dodge
blending mode and apply to the highlights to
increase their glow and intensity. A few small
tweaks to the layer contrast and use of the 'replace
colour' technique and the hair shading is done.

STEP 10

Colourizing parts of the hair and adding
coloured highlights can be great fun and adds
an extra twist to your character. There are
a couple of different ways to do this. Using
the 'Color' blending mode on a brush, as
explained in the secondary lighting to skin
lesson on page 89, is one option but it can
make editing the new secondary colour a little
more tricky, so I prefer to work on a clear new
layer above the hair layer.

Create a new layer called 'H colour'. Create a
selection encompassing the existing hair layer
boundaries by clicking the Hair layer while
holding down Ctrl / Cmd on the keyboard.
Choose a second hair colour, in this case, blue.
With a soft, low-flow brush, paint in the second
colour towards the tips of the hair. Change the
H colour layer to the Colour blending mode.
Optionally, add an additional third colour
towards the ends of the tips.

STEP 11

Work through rendering the
remaining layers using the
techniques mentioned so
far, until the clothing and
accessories are complete.

STEP 12

The next step is Pattern Overlay. Source a suitable pattern for the clothing. This can be a scan, a photo you have taken, a stock photo or a Google search, but make sure the image dimensions are as high as possible to ensure the best quality. I've chosen a floral stock image tile for the kimono-style outfit.

STEP 13

Open the pattern image, then duplicate and tile it. To do this, enlarge the canvas using the Crop tool or Image –> Canvas Size [Alt+Ctrl+C / Opt+Cmd+C]. Make the image layer editable. Duplicate the layer and place a tile next to it. Holding Shift while dragging the image into position keeps the layer contents parallel. Adding a Snap [Ctrl+Shift+; / Cmd+Shift+;] will help arrange these to fit perfectly next to each other.

Merge the layers, then duplicate and place next to the existing layer content. Repeat this process to build up a series of tiles next to one another.

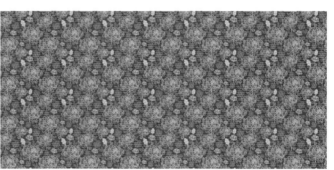

STEP 14

Copy the pattern to the character image by selecting the pattern layer content [Ctrl+A / Cmd+A] then pasting it on to the Yuki canvas [Ctrl+V / Cmd+V]. Now position this over the Kimono layer. Select the Kimono content by clicking the layer on the layer panel while holding Ctrl / Cmd. Invert the selection: Select –> Inverse [Shift+Ctrl+I / Shift+Cmd+I] then press delete on the keyboard. Deselect the selection [Ctrl+D / Cmd+D].

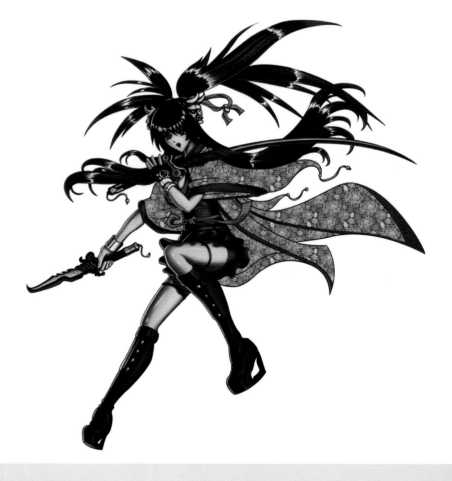

STEP 15
Set the Pattern Overlay layer to a blending mode called Overlay. Tone it down a little by reducing the layer's opacity to 80%. Rather than using Overlay, experiment by toggling through the different layer blending modes and you might find an interesting effect you hadn't planned on.

STEP 16
Because of the crimson tone underneath, some of the yellow and purple tones of the pattern are lost. To combat this, select the crimson Kimono layer and desaturate it: Image –> Adjust –> Desaturate. Tweak the Levels to lighten and increase contrast – I've set Shadows to 5, Midtones to 1.2 and Highlights to 120. Adjust the Hue/Saturation level. I've set it to 'Colorize' and changed the Hue value to 330, Saturation to 20 and Lightness to –5.

STEP 17
Repeat the pattern overlay process to add any other trim patterns or details – in this case I've added some patterning to the belt. Finish by adjusting any layer colours, contrast levels or settings until you're happy with the resulting image. After merging all the character elements, I added a subtle inner glow in white.

CHAPTER 7
UNDER ARREST!

This section will look at an undercover cop of the near future – Jake Yamazaki. With this guy, we'll be going back to our cel-style shading and looking at how to combine it with a separate hand-drawn background.

Then we'll lay a few sound effects and a speech bubble on top, along with some speed lines to give the image a manga-style comic-book feel.

Mini-tutorials

▲ Creating a separate character: cel colouring

▲ Creating a separate background: textured brushes

▲ Tying things together: colour overlay, ground shadow

▲ Sound FXs

▲ Speech bubble

▲ Action/speed lines

Rendering style

▲ Cel, working with brushes

Internet

▲ Tutorial video and materials download: http:// digitalmanga.organicmetal.co.uk

ADDING A BACKGROUND

Sometimes it can be a great idea to keep the character artwork and background completely separate. This not only makes colouring background elements easier because you don't have to mask off or work around the character, but it's also easier to tweak perspective, styles or colour schemes of either the background or character art independently.

STEP 1

I've started by designing a Jake sketch. I wanted to keep him in casual, modern clothing, as he operates his policing duties undercover. I placed him in a dynamic pose – perhaps he's about to scout the area while on the hunt for a suspected criminal?

STEP 2

From here, scan the drawing into Photoshop and make any necessary tweaks and amendments. In this instance I decided to flip Jake horizontally, then saved the file. I printed off this amended version and redrew it by hand, tracing with a pencil on a lightbox (or you could trace against a window). Once redrawn, I scanned it into Photoshop and cleaned it (see pages 52–7).

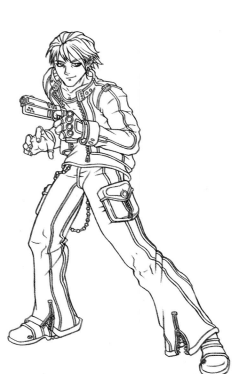

STEP 3

Next, hand-draw a city alleyway for the background. Keep in mind how big you want the character to be when drawing the perspective of the buildings. Scan into Photoshop, and save.

STEP 4

With the background image opened, open the character sketch to plan where you want him placed. Copy the character to the background image and place him on a layer above the background. Make him bigger or smaller using the Transform tool and choose where to position him, deciding on how far forward he will be situated so that he is proportioned correctly in relation to the background. The blue image shows an ideal placement. The red one could also work, although it's a little too small for this drawing unless you decide to crop the background image to make it smaller too.

STEP 5

Colour Jake, starting with the usual process of flatting as described on pages 60–61.

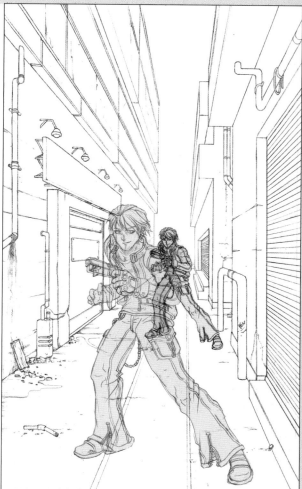

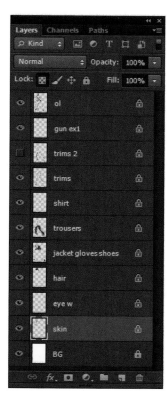

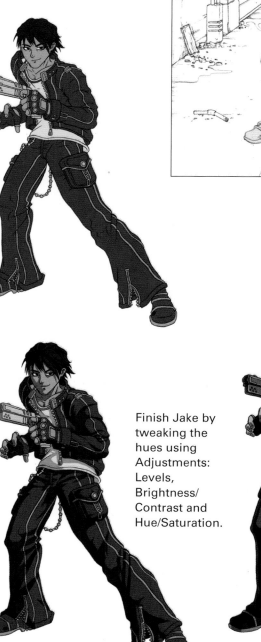

I've gone for a simpler cel rendering with a single pass of shadows and softened these a little by using a blur filter with a radius of 4: Filter –> Blur –> Gaussian Blur.

Finish Jake by tweaking the hues using Adjustments: Levels, Brightness/ Contrast and Hue/Saturation.

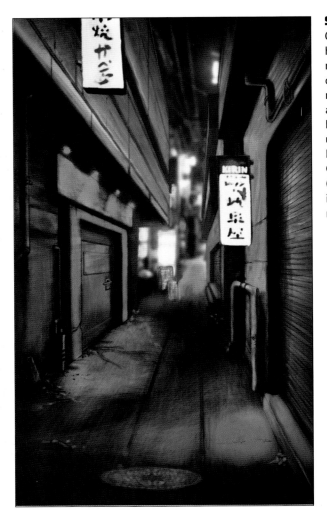

STEP 6

Colour the alley. Using grey hues, create a 'value study' (a monochrome image concentrating on contrast rather than colour) to make sure the lights and darks are in the right place. To give the background a rough, textured look, use a thick, heavy brush from the Brush Presets menu and a few Googled images for reference (photo elements have been added in the distance – see Chapter 10 for more on photo manipulation).

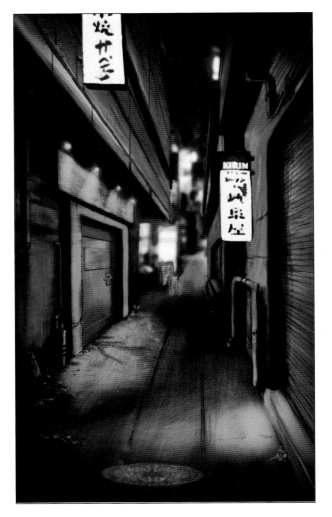

STEP 7

Add colour to the background by creating a second layer and set its blending mode to 'Color'. It's easy to put a lot of time into details with the background, but the trick is to keep it simple, with this one being more like a speed painting. Merge this colour overlay with the rendered layer beneath and name it 'Background'.

I decided to render the background on a single layer with just the Line Art layer above as a guide. Merge the Line Art layer with this rendered layer by going to the Layers menu and selecting Merge Down [Ctrl+E / Cmd+E].

STEP 8

Using the plan in Step 4, excluding the white, merge all the Jake colour layers to a single layer by going to the Layers panel menu and selecting Merge Visible [Shift+Ctl+E / Shift+Cmd+E]. Copy Jake to the coloured background image on a layer on top and name the layer 'Jake'. Use the Transform tool to adjust him to the appropriate size.

STEP 9

To tie his colour tones in with the background, add a colour overlay. To do this, add a new layer on top named 'Overlay'. Ctrl+Click / Cmd+Click on the layer thumbnail for Jake. This will create a selection covering all coloured pixels. With the Overlay layer selected, fill it with a solid blue. Deselect the selection [Ctrl+D / Cmd+D]. Lock transparent pixels on that layer and use a brush to add in secondary yellow light. Adjust the opacity of this layer to help you see where the secondary light will fall.

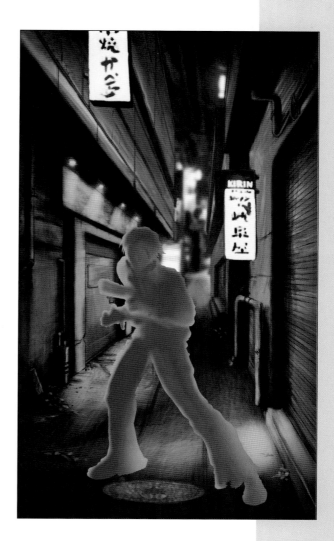

STEP 10

Set the blending mode of the Overlay layer to 'Color' and reduce the opacity to 40%.

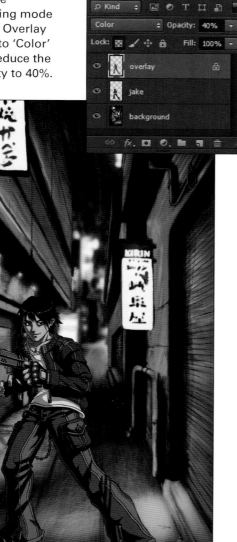

STEP 11

Create a layer between Jake and the background called 'Shadow'. Use a dark blue or black with a brush to add shadow on the ground underneath the character. Set the opacity of this layer to 50%. The ground shadow layer will look something like this (minus the character silhouette, of course).

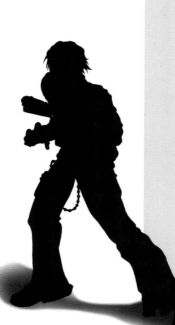

ADDING SOUND EFFECTS

As well as using onomatopoeic words such as 'boom', 'swoosh' and 'pow' to illustrate the sound of an object falling, a door being flung open or a person throwing a punch, the Japanese manga industry uses hundreds of sound effects for things that are normally soundless to express certain actions or emotions. For example, a sound effect can be used to express night falling, the sun disappearing, eyes closing or someone feeling bored! There's pretty much a sound effect for every occasion.

STEP 12

To create a rumbling sound effect to denote tension, make a new layer between the background and character layers. Name it SFX. Click the eye next to each layer, excluding the SFX layer – this will make it easier to see what you're doing. Select a hard brush and draw a blocky back-to-front C shape with two little accents to the right. This is the Japanese symbol 'Go' and multiples, i.e. 'go-go-go-go'. It is used as a sound effect in a manga to indicate rumbling and to add tension to a scene.

STEP 14

Position the sound effects behind the character and add a gradient to each symbol. This can be done using either the Gradient tool or a large, soft brush. Right-click the SFX layer and click Blending Options. Add a white Stroke, which will create a white outline around each symbol.

STEP 13

Duplicate the layer [Ctrl+J / Cmd+J] and free transform [Ctrl+T / Cmd+T] the second symbol to be a little smaller, rotated clockwise a little and moved to the right. Repeat twice more so you end up with an arc of text.

STEP 15

Create a new layer at the top called Bubble1. Use the Elliptical Marquee tool to make a circular selection. Create a spike coming off the selection using the Polygon Lasso tool while holding down Shift to add to the selection. Fill the selection with white. Add a black Stroke to the bubble. Make sure the Stroke position is set to 'Inside' for a crisp outline.

STEP 16

Select the Type tool and click inside the bubble. Type the required text. Adjust the font size to fit by using the tool options, or the Character menu panel. For an authentic comic font, I tend to use 'LetterOmatic!', which produces all text in upper case. Go back to the bubble layer and adjust, if necessary, for a better fit.

FINAL TOUCHES

STEP 17

To add action/speed lines found in typical manga, create a new layer on top named 'Lines'.
Select the Line tool and set the line weight (thickness) in the tool options bar.

Find a central point on the image where the lines will meet. Draw a line from this central point to the edge of the canvas. Repeat a few dozen times until you have created enough action lines in a spider-web pattern, increasing the weights of some of the lines, then use the Eraser to rub out and taper lines towards the middle. It's also possible to create pre-tapered action lines via the tool options bar Arrowhead setting – check either the start or end boxes, then set the arrowhead width to 100% and the height to 1000% or more. Now click and drag to draw a line as usual. The trouble with the pre-tapered line method is getting the angle and direction of the lines right, so that all converge on the same single central point. The action lines can be either white or black. I've used black this time for a more subtle effect and adjusted the layer opacity to 50%. I've finished the image with an orange overlay layer.

Timing

People often ask how long it takes to finish an artwork like this. There's no definitive answer as each piece is different and anyone attempting such an image might be quicker or slower depending on their experience or technique. For this image, I estimate:

▲ 2 hours for the initial sketch
▲ 3 hours to amend, redraw and clean the line art
▲ 40 minutes to flat the character
▲ 1½ hours for character shading
▲ 1½ hours for background colouring
▲ 1 hour to tie the character and background images together
▲ 1 hour for final touches

That makes nearly 11 hours in total. Perhaps I could have done it in half that time if I were not too concerned about the overall finish. However, I have been known to spend 70–80 hours on something like this when I wanted to make the details sharper and the quality higher.

CHAPTER 8
FUTURISTIC FIGHTER PILOT

Technology and sci-fi are the staple diet of many Japanese manga fans. By following the creation of futuristic fighter pilot Mizuki, you will discover how to halve your workload by using symmetry flip; how to save time by duplicating finished character artwork to create an army; and how to add a vertical reflection. There are also tips on how to create metal elements, neon glows and shines.

Mini-tutorials

▲ Adding colour

▲ Rendering metal

▲ Glows/shines

▲ Duplicate and flip

▲ Multiply and reflections

Rendering style

▲ Soft CG

Internet

▲ Tutorial video and materials download:

http://digitalmanga.organicmetal.co.uk

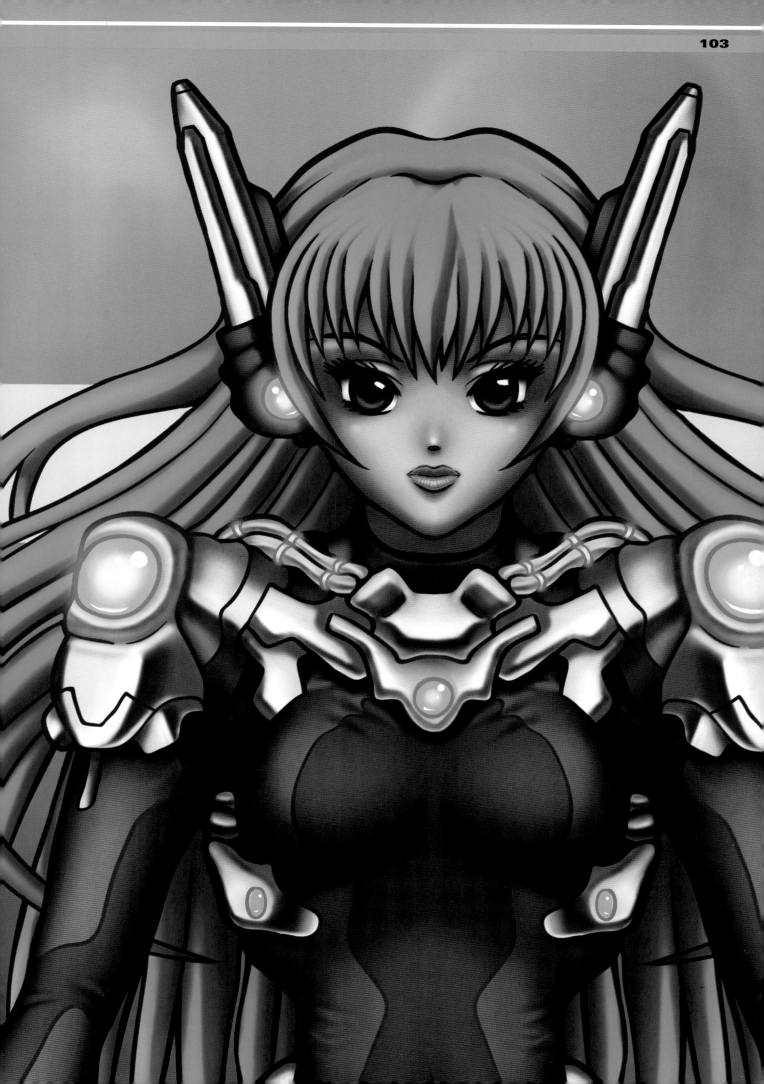

SYMMETRY

Flipping symmetrical artwork is a huge timesaver, as you only have to draw the left or right side of a character then duplicate and flip it to create the whole design.

STEP 1

Start with a tablet-drawn sketch. I've decided to give Mizuki a tight-fitting outfit with armoured areas on the shoulders and hips. I imagine she would be a pilot for some kind of giant robot/mecha.

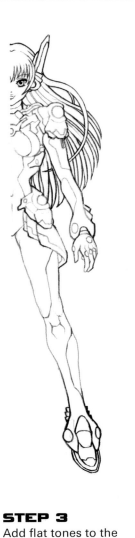

STEP 2

After Step 1 you could duplicate then flip the half character either before or after the inking process, then continue to lay flats and render as usual. Duplicating and flipping at this stage is particularly necessary if you're intending to produce a directional light source at the colouring stage, where shadows will be cast either to the left or right of the design.

However, if you're using a front-central light source, it is possible to halve the rendering work by duplicating after the colouring stage. A central light source will be demonstrated for this tutorial.

Digitally ink the design and prepare it for colour (see pages 48–9). Keep some outline overlap towards the centre of the image.

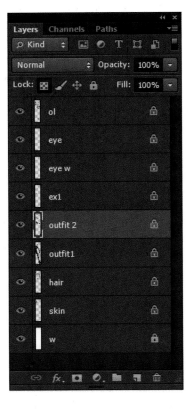

STEP 3

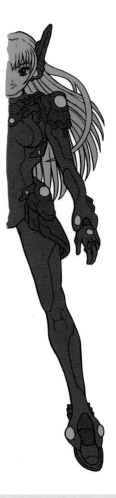

Add flat tones to the character (see pages 60–61). Keep in mind that there will be gaps to fill in manually with a brush, so making use of the Magic Wand then expanding pixels is not always an option.

STEP 4

Add rendering, shading and highlights to the image. Remember to keep a neutral, central light source so that once this half is duplicated, the second half won't look out of place by using conflicting light sources.

STEP 5

After the skin, hair and outfit layers are completed, move on to the Armour layer. Rendering and shading metal requires a similar process to regular shading, except that a higher contrast between the light and dark shades is typically used. Metal can also become reflective depending on how shiny the surface is. Extra reflection detail is particularly required when creating a chrome look.

STEP 6

Add a first pass of shading over the armour, as with any other part of the character.

STEP 7

For the armoured parts, the basic idea is to have a dark tone butting up against a highlight tone towards the edges of each facet, bend or fold.

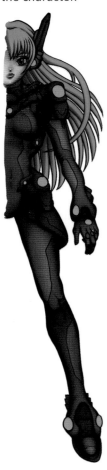

Use the Levels adjustment to significantly raise the contrast of the armour. If the tone becomes too saturated with colour this can be altered via the Hue/Saturation adjustment. It's also possible to play around with the Brightness/Contrast adjustment sliders.

Once a high-contrast tonal level has been achieved, add some subtle purple into the mix to denote a degree of reflection from the purple outfit. This can be done by using a brush with its blending mode set to 'Color' via the tool options bar. The purple is added to the edges of the armour next to purple parts of the outfit.

For this stage, it may be worthwhile duplicating the Armour layer. Working on this duplicated layer means you can delete it if you make a mistake or overdo any Levels adjustments. Also, if the purple colour on the armour has come out too strong, it can be toned down by adjusting the duplicate layer's opacity setting and blending it in with the original Armour layer beneath.

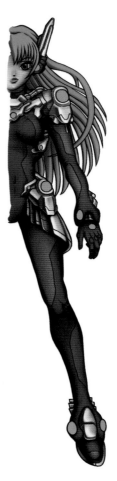

GLOWS AND ORBS

Design elements found in many sci-fi inspired works are neon glows to symbolize energy-powered equipment or circular orbs which can be used to fire laser projectiles.

Mizuki has several circular orbs on her outfit. Although not necessary, it's preferable to have these in the same colour to help limit the palette and tie the design together.

STEP 8

To create glows, start with a blue base colour and add a lighter, whiter blue value towards the centre of the circles using a low-flow brush.

Click the small FX icon at the bottom of the Layers panel and select Outer Glow. From here change the blending mode from Screen to Normal, Opacity to 70%, add a blue-coloured glow rather than the default white, and adjust the glow strength using the Spread and Size sliders. In this instance, Spread is set to 15% and Size to 130 pixels. Click OK when you are happy with the result.

To complete the effect, select the Outline layer, make sure its transparent pixels are locked and colour around the circles using a blue tone and brush tool.

STEP 9

For shiny orbs, create a gradient from dark blue or black at the top of each orb and lighter blue at the bottom. On a new layer above, use a hard white brush to paint in the highlights. This is similar to rendering the eyes of a character. I usually place these 'shines' towards the top left or top right for best effect, but placement also depends on where your light source is. To keep the light source consistent, these shines will later need to be adjusted after the character half has been duplicated and flipped.

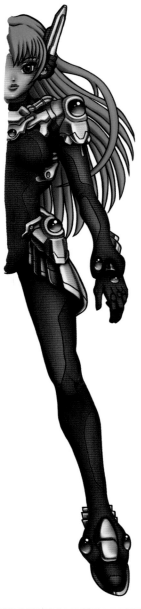

You could also combine the glow method with the light shines to create a glowing, glossy orb. Then colourize outlines to finish this character half.

DUPLICATE AND FLIP

STEP 10

After the colouring process is complete, use the Crop tool to enlarge the canvas or go to Image –> Canvas size and double the width. Merge all layers except for the white background and name this new layer 'Right Half'. Saving a copy of this file is a good idea in case you want to go back to editing individual layers.

STEP 11

Make a copy of the Right Half layer. Name it 'Left Half' and make sure it is above the Right Half in the layers panel. Then flip the contents of this layer: Edit –> Transform –> Flip Horizontally. Use the Move tool to drag the Left Half layer to the left. Hold Shift while you do this to constrain the movement to a straight line and match this up with the Right Half layer below.

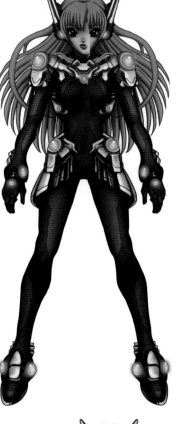

STEP 12

There will be excess image overlapping which will need to be removed. Use a soft Eraser to do this. There will also be certain parts which don't quite match up in the middle – particularly the hair and the chest orb, as they weren't 100% symmetrically central when originally drawn. Repaint these in afterwards using the Brush tool to fix errors and hide any seams. When correcting parts of the image at this stage, the process is similar to a flat photo-retouching exercise and you won't be able to rely on the luxury of individual layer editing. Finish this step by repositioning the light on the eyes and orbs and adjusting the eye size and position, using a combination of Lasso selecting, Transform and Brush touch-ups. Then merge the Left Half and Right Half layers.

STEP 13

When finishing and merging colour layers, it's advisable to spend time making some final adjustments to hues and tones. In this example, go to Image –> Adjustments –> Color Balance and adjust the Red, Green and Blue sliders for Midtones, Shadows and Highlights. This process is done 'by eye' to create the desired effect – in this case, creating a more uniform, warmer range of tones by primarily increasing the reds.

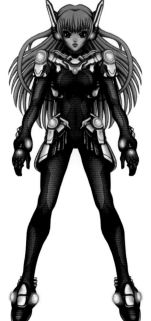

This process can make colours a little overpowering, so go to Image –> Adjustments –> Vibrance and lower the vibrancy level with the slider to tone down the colour values.

STEP 14

To create an army of Mizukis, increase the canvas size and duplicate the character layer as before. Move the second character copy beneath the first and use the Transform command to scale down the image. Position it above and to the side of the original character layer to create a sense of perspective.

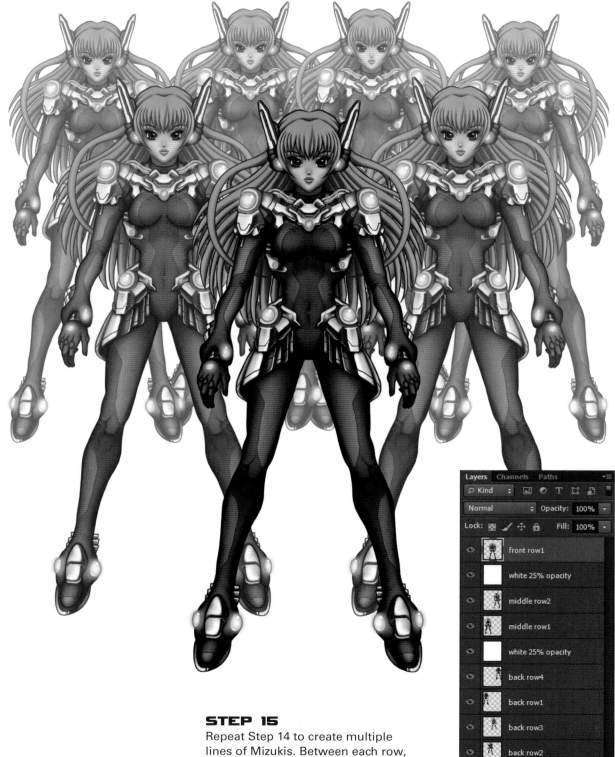

STEP 15

Repeat Step 14 to create multiple lines of Mizukis. Between each row, add a new layer and fill it with white, then set its opacity to 25%. This will create some depth by fading out the Mizukis towards the rear of the art.

CREATING A GROUND REFLECTION

STEP 16

To create a ground reflection, double the canvas height, duplicate Mizuki and name the duplicate layer 'Reflection'. Flip the duplicate: Edit –> Transform –> Flip Vertically, so that the toe tips are touching. With the Reflection layer selected, click the 'Add Vector Mask' icon at the bottom of the Layers panel. Make sure the Layer Mask thumbnail (situated to the right of the Layer thumbnail) is highlighted – this is indicated by the white corners. Add a black to white gradient fill on to this Layer Mask, starting from the character's mid-point and dragging it up to the toes. Finish by adjusting the Reflection layer opacity to 80%.

CHAPTER 9
WAR GAMES

The artwork for military commando Justin Silver reveals how to create seamless textures and patterns and apply a range of camouflage styles by making use of Layer Masks. Military themes, soldiers and guns dominate much of the video game industry and feature in many manga stories, so getting to grips with these character elements and effective shortcuts can be a great addition to your arsenal of techniques.

Mini-tutorials

▲ Adding colour

▲ Creating a seamless tile

▲ Pattern mask

▲ Adding logo/warp

Rendering style

▲ Soft CG

Internet

▲ Tutorial video and materials download:
 http://digitalmanga.organicmetal.co.uk

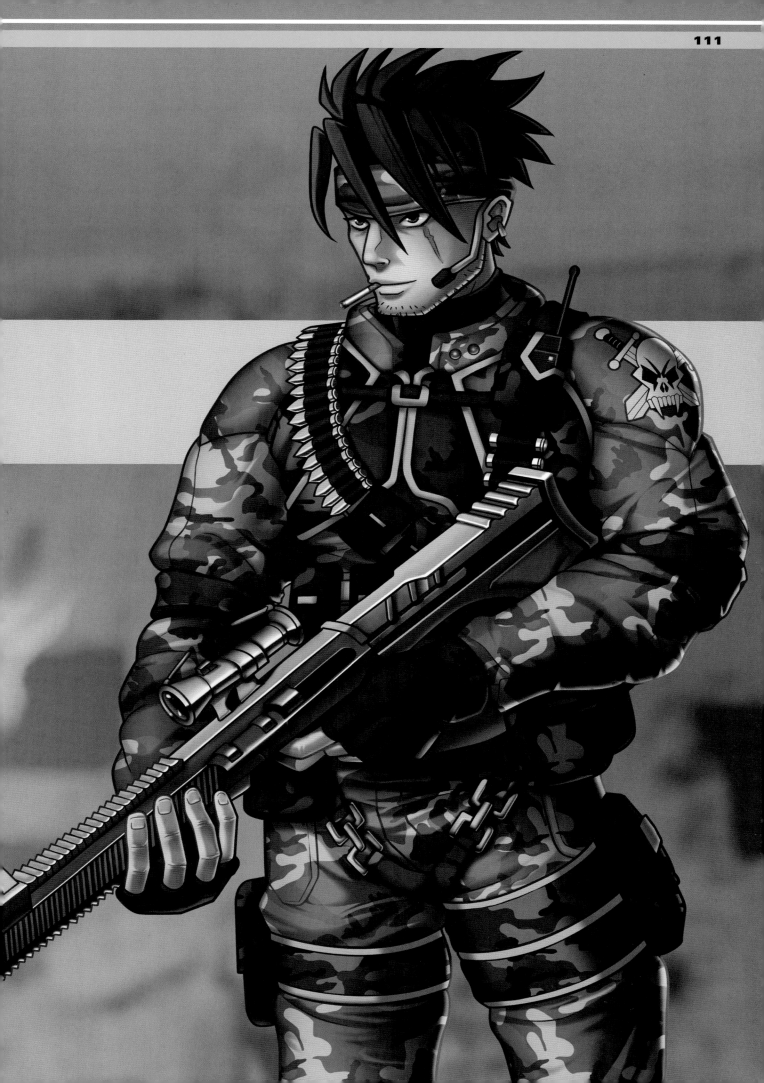

RENDERING

Here I explain how to render Justin, an elite military commando fighting battles in a futuristic era. He doesn't always play by the rules, but he always gets the job done.

STEP 1

Start with a pencil drawing and scan it into the computer. The line art has been kept fairly neat to make it easier to follow at the inking stage. Working with a looser, sketchier drawing is fine, if you prefer it and can make sense of the pencil lines at the inking stage.

STEP 2

The drawing is digitally inked for crisp, clean lines (see pages 48–9). I made a few small corrections to some of the lines at this stage.

STEP 3

The flats are laid as usual on their respective layers (see pages 60–61)

I was undecided about outfit colours, so I broke up various elements into different grey shades: Layer 'Cloth 1 L' for light grey used on the main clothing, 'Cloth 2 M' for a mid-grey used on boots and straps, and 'Cloth 3 D' for a darker grey used on gloves and pouches, with a much lighter grey for 'trims'.

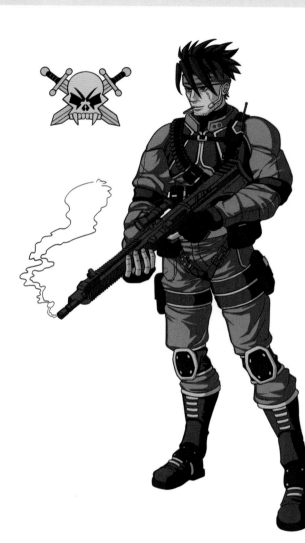

STEP 4

With a left-hand light source in mind, I began to plan out where shadows would go, using a hard brush to create a cel-style technique (see pages 62–5).

STEP 5

Then, using soft, round brushes of varying flow between 5% and at times 100%, I started to soften the edges and add extra shadow where necessary. As with earlier examples, this step is a case of:

▲ Zooming in and out of the image when necessary to focus on adding various details (most often working in a zoomed-in state)

▲ Constantly increasing and decreasing brush sizes to fit within the areas to be shaded

▲ Occasionally making use of the Smudge tool to create tapered shadow or highlights

▲ Sometimes setting a soft, low-flow percentage brush mode to Multiply to further darken areas with existing shadows

▲ Tweaking each layer's contrast after completing the rendering using Levels and Brightness/Contrast adjustments

▲ Colouring the Line Art layer

ADDING CAMOUFLAGE PATTERNS

In warrior girl Yuki's tutorial I demonstrated how to add a floral pattern overlay to her outfit (see pages 92–3). Adding a camouflage overlay to Justin's uniform can be achieved in a similar way although, as with many Photoshop effects, there's more than one way of getting the job done and different methods will have different advantages and disadvantages. As with the Yuki tutorial, textures and patterns can be sourced from the internet and from stock image websites. Patterns can also be created from scratch in Photoshop, then repeated or tiled on to a layer or selection using the Paint Bucket tool or layer effects.

STEP 6

To create a pattern, open a new canvas of equal pixel dimensions such as 1000 x 1000 pixels. Use the Brush tool to paint a military camo design, using reference material if needs be.

STEP 8

There are obvious straight-edged seams towards the top and left edges. Use the Brush tool to cover up and blend away these seams, but be very careful not to take the brush up to the edges of the tile while doing this.

STEP 7

In order to turn this pattern into a seamless texture or tile, go to Filter –> Other –> Offset. Set the Horizontal value to 200 and the Vertical value to 100, with undefined areas set to Wrap Around. Now you are presented with a tile where the shapes on the right margin will marry with those on the left margin and the top edges will marry with those at the bottom.

Go to Edit –> Define Pattern and name the tile 'Camo1' in the dialogue box, then click OK. This will now be saved within the default Photoshop Patterns library and can be accessed and made use of later as an automatically repeated/tiled pattern. It can be viewed, deleted or renamed through the Presets Manager.

Installing pre-made patterns

Some internet sites provide pre-made Photoshop pattern files and pattern libraries – you will find a good selection of pre-made camo patterns at this Deviant Art link: http://fav.me/d2b4sk5. After downloading patterns, store them within the Photoshop Patterns directory on your computer hard drive. The hard drive directory to copy and paste downloaded PAT pattern files to is:

For Windows Vista, 7 and 8:

Users/[user name]/AppData/Roaming/Adobe/Adobe Photoshop CS6/Presets/Patterns (the AppData folder is hidden, so turn on 'Show hidden files' in Folder Options)

For Windows XP:

Documents and Settings/[user name]/Application Data/Adobe/Adobe Photoshop CS6/Presets/ Patterns

For Mac OS:

Users/[user name]/Library/Application Support/Adobe/Adobe Photoshop CS6/Presets/ Patterns

STEP 9

Adding a layer mask enables you to hide unwanted portions of underlying pattern and preserves the pattern as a whole, which allows you to reposition or edit the pattern independently. Go to Edit –> Presets –> Presets Manager, select the 'Patterns' Preset Type from the drop-down box then click 'load'. You should be able to select the PAT file you pasted to the appropriate directory earlier.

Create a new layer above the 'Cloth 1 L' layer and name it 'Camo Pattern'. Select the Paint Bucket tool and change the fill mode from 'Foreground' to 'Pattern' via the tool options bar.

Next to the Fill mode option is a drop-down panel which houses various preset patterns. If the camo pattern you want to use is there (after having completed Step 8 or the method described above), click the thumbnail to select it. If not, you may need to locate the relevant pattern by clicking on the small settings cog icon at the top right of this panel and choosing the required pattern library from the list.

Next, click Append or OK to add these patterns to the pattern drop-down panel.

STEP 10

Click the canvas with Camo Pattern selected to fill the layer with a tiled pattern. Ctrl+Click / Cmd+Click the Layer thumbnail for 'Cloth 1 L'. This will bring up the 'marching ants' selection around the elements on this layer.

With Camo Pattern still selected, click the Add Vector Mask icon. As with the Mizuki ground reflection tutorial, you'll notice a second black-and-white Layer Mask thumbnail image next to the first Layer thumbnail, with a chainlink icon between.

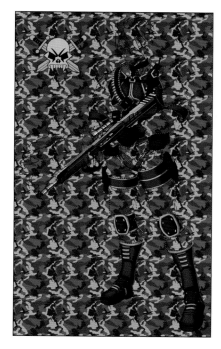

STEP 11

Set the Camo Pattern layer blending mode to Overlay. Tone it down a little by reducing the layer's opacity to 90%. Steps 9–11 can be repeated for layers 'Cloth 2 M', 'Cloth 3 D' and 'Trim'.

With the Mask Layer thumbnail selected, use a black brush to add to the mask (or white to subtract). This can be used to erase any camo pattern not required on parts of the image.

STEP 12

Swap Camo Pattern layers and adjust some of the tones to create combat gear suitable for various environments. For the first example I used a 'US woodland' style of pattern. You might want to test out digital urban, desert or arctic warfare styles too.

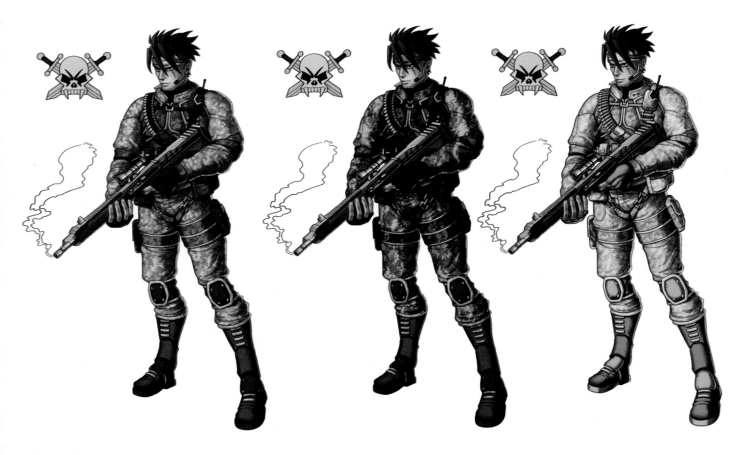

LOGOS AND FINISH

Logos can be created separately from the character then stuck on towards the end, allowing them to be manipulated or duplicated without interfering with the rest of the artwork.

STEP 13

To add the skull and swords insignia as a patch to the outfit, create a duplicate of the image before merging all layers except for the white background. Use the Lasso tool to create a selection round the logo, then cut and paste it to a new layer and name the layer 'Logo'. If you want to put the logo in several places on the outfit, duplicate the Logo layer and hide the duplicate – it can be unhidden and used or reduplicated later on.

With the Logo layer selected, go to Edit –> Free Transform [Ctrl+T / Cmd+T] and begin to position, rotate and resize the logo to fit over the soldier's left shoulder.

Use the Transform commands Warp and Perspective and adjust the corresponding anchor nodes to shape the logo, making it more spherical and 3D to fit onto the round part of the shoulder.

STEP 14

Add a little shading to the logo, using a brush set to Multiply. Trim off any overlapping excess parts of the logo. Add a dark outer glow layer style to the logo to finish it off.

STEP 15

For the finishing touches:

▲ Add gun barrel smoke with a brush, reducing the smoke layer opacity to make it more see-through
▲ Add a ground shadow with a soft black brush
▲ For the photo background, see pages 124–5 for instructions
▲ A blue gradient layer overlay ties things together; set the blending mode to pin light and the layer's opacity to 60%.
▲ Adjust hues, values and tones where necessary

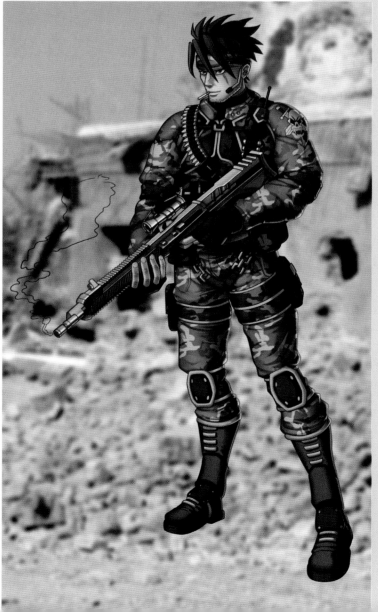

CHAPTER 10
GOTHIC LOLITA

Manga fans will be familiar with the popular subculture of Lolita. It became fashionable on the streets of Japan during the late 1990s and has continued to expand into various spin-off styles. In Japan, the term Lolita refers to 'cuteness', 'elegance' and 'modesty' and does not have the sexual connotations suggested by the name in Western culture. From Gothic Lolita you will learn how to add clothing trim and accessories, alter colour combinations, use colour overlays and create a completed illustration by adding a photo-manipulated background.

Mini-tutorials

▲ Adding colour

▲ Adding decoration – bows and lace

▲ Colour overlays

▲ Theme colour adjustments

▲ Adding and manipulating a photo background

Rendering style

▲ Cel

Internet

▲ Tutorial video and materials download: http://digitalmanga.organicmetal.co.uk

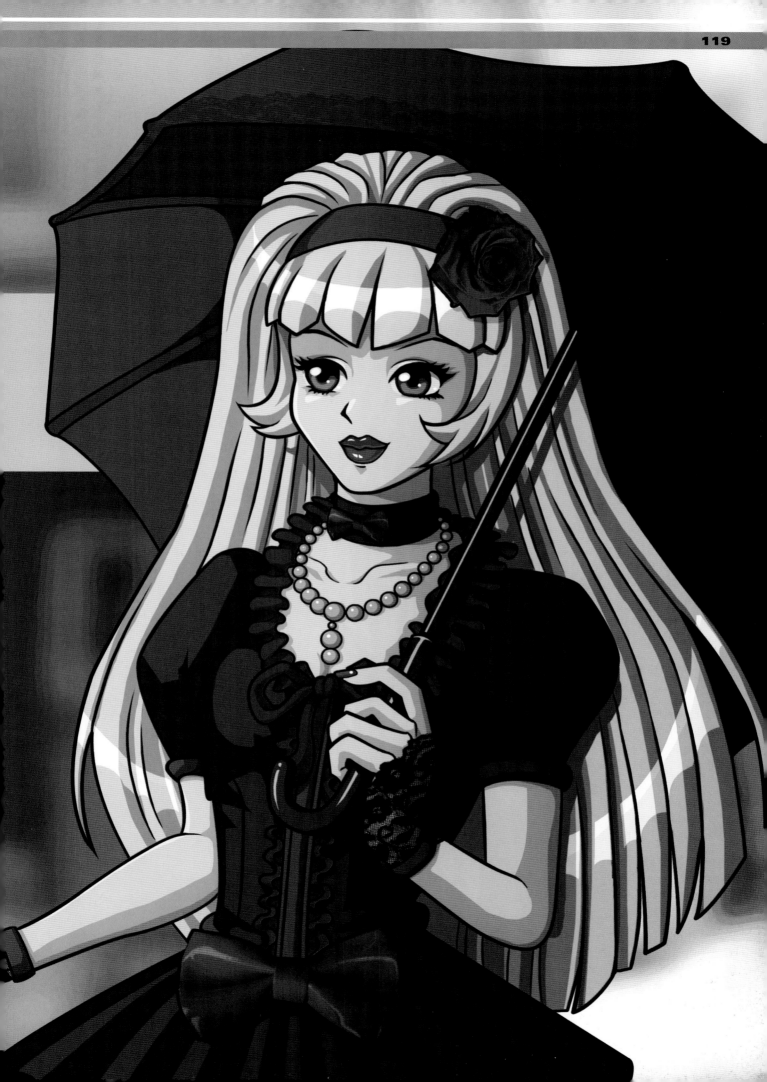

GOTHIC LOLITA STYLE

Gothic Lolita style is based on Victorian-era clothing with a dark edge, on the 'visual kei' genre and on Goth rock bands.

With some colour alterations you will find it possible to mimic other fashion variations too.

STEP 1

Start with a pencil drawing and scan it into the computer. The intention is to go for a sort of baby doll, 'Alice in Wonderland' look.

STEP 2

To make things clean, clear and easier to colour, digitally ink the artwork (see pages 48–9).

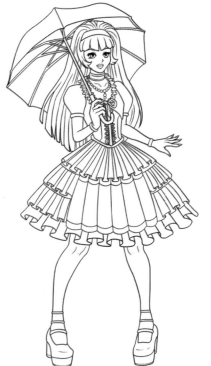

STEP 3

Lay down flat tones (see pages 60–61). Lay an extra flat for the legs and hide the layer for the moment. You will use this layer for socks/tights on alternative versions of the image at a later stage. Also, optionally, divide the skirt into three layers (one for each row of folds) to make it more manageable when it comes to shading.

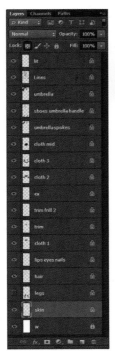

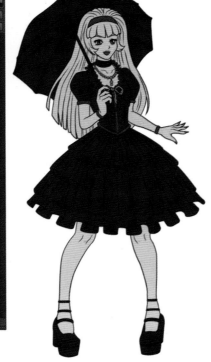

STEP 4

Add shadows and any necessary highlights. Keep the light source in mind – it will be coming primarily from the right-hand side. Use the methods explained on pages 62–5 to create an anime cel look.

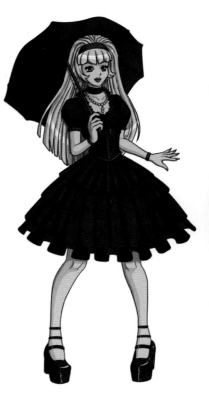

ADDING ACCESSORIES

As with textures and pattern overlays, you can add photographic or predrawn objects and elements to an illustration, just like making a collage. Using a library of objects or sourcing suitable accessories and elements from the internet can be a great timesaver.

STEP 5

To add a bow, source a stock image or photo. Open it in Photoshop and unlock the flattened Background layer by pressing Alt and double-clicking it in the Layers panel. Cut out the bow from the background. To do this use the Magnetic Lasso, found in the Lasso tool's flyout menu. Dragging it round the edges of the bow works well on an image where the contrast between object and background is high. Right-click the lassoed selection, choose Select Inverse and press delete on the keyboard to remove unwanted background, leaving the grey checkerboard background in its place.

Use the Hue/Saturation adjustment to colour the bow a suitable shade – in this case, red. Then adjust Brightness/ Contrast levels, if necessary.

STEP 6

Copy and paste the bow on to the Lolita image on a layer above the Line Art layer and name it 'Bow'. This layer can now be duplicated as many times as necessary and each bow layer can be positioned, resized and rotated accordingly to fit on to parts of the image using Free Transform. You can also use the Warp and Perspective Transformation commands to manipulate these images further.

Place a larger bow around the belt area, a few on Lolita's dress, one on her collar and one on each shoe. Add a 4–6 pixel-width black Stroke layer effect to each of the bows to mimic the outline around the rest of the image and tie them in more.

Also add some shading to the bottom left portions of these bows to indicate cast shadows. This can be done with a brush and black on a new layer with its blending mode set to Soft Light.

STEP 7

To add lace, source a sample of lace trim, edit it and paste it on to a new layer on the image in the same manner as the bow.

STEP 8

Duplicate the lace layer a couple of times and position a copy over each hand. Shrink the sample down using Free Transform, then use the Eraser to rub out any excess to create a fingerless glove effect.

Use another duplicated lace layer to create a trim beneath the skirt. This can be done by positioning several lace samples next to one another to create a line of trim. From here, use the Warp Transform to curve the trim so that it follows the bottom curvature of the skirt. In Free Transform mode it's possible to switch to Warp mode by clicking the Warp icon on the properties bar at the top.

Add some lace trim to the umbrella and a rose to Lolita's hairband at the side, using the same techniques.

ADDING OVERLAYS

In Jake's tutorial (see pages 94–101) I used colour overlays and lighting effects to tie in the character art and background image. There are endless possibilities and effects you can add to enhance illustrations. The following steps show just one way of doing this.

STEP 9

Further define the left-hand light source by adding a light overlay coming from the right. To do this, pick a large, soft 50% opacity brush and select a white foreground colour. Add a loose spread of white tone around the right edges of the figure. Now set the layer blending mode to Soft Light and the layer opacity to 35%.

STEP 10

Further define the shadows by adding a dark overlay towards the left. Add a grey spread of tone coming from the left. Set the layer blending mode to Vivid Light and the layer opacity to 35%.

STEP 11

Add a coloured light source from the bottom right. To do this, select the Gradient Fill tool and drag a red to transparent tone over the image, starting in the bottom corner. Set the layer blending mode to Overlay and the layer opacity to 50%.

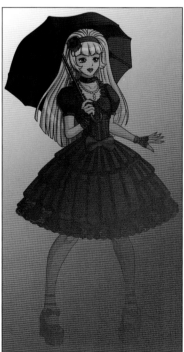

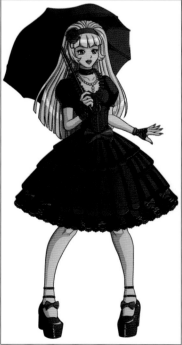

To stop the excess tone on these overlays from interfering with the background image, which will be added in Step 14, create layer masks (see pages 114–117). I also altered the eye colour to brown.

ADJUSTING COLOURS

As well as 'Gosu rori' (GothLoli), there are various Lolita sub-categories. To name but a few: Kuro Loli (all black), Shiro Loli (all white), Sweet Lolita (pastels and/or cute prints), Classic Lolita (Rococo, Regency and Victorian influences), Country Lolita (gingham patterns and straw baskets), Punk Lolita (chains, safety pins and tattered fabric) and Wa Lolita (traditional Japanese clothing styles).

Using the Hue/Saturation sliders and Levels adjustments, it's possible to create alternative outfits easily in minutes. Before starting an alteration process it's a good idea to save and work on a new copy of the file, or go to Image –> Duplicate to begin working on a second copy while retaining the original.

STEP 12

To create a pink Sweet Lolita variant, systematically go through each layer applying adjustments to the different outfit elements. The main colours to change are shown in this panel.

For lace gloves and skirt trim: Image –> Adjustments –> Invert [Ctrl+I / Cmd+I]. Then add a red stroke at 50% opacity via the Layer FX icon.

Layer/s	Level adjustments	Hue/Saturation adjustments
Dark clothes, shoes	Shadows: 0 Midtones: 1.30 Highlights: 80	Hue: 350 Saturation: 70 Lightness: 70 +check Colorize box
Umbrella	Shadows: 0 Midtones: 1.30 Highlights: 25	Hue: 360 Saturation: 30 Lightness: 60 +check Colorize box
Bows and reds	Shadows: 0 Midtones: 1.20 Highlights: 25	Hue: 360 Saturation: 60 Lightness: 60 +check Colorize box
Lips and nails	N/A	Saturation: 0 Lightness: 40

To give Sweet Lolita a pair of tights, unhide the leg flats layer created earlier, colour it a light grey and set its layer blending mode to Hard Light. Particularly when working with light or pastel tones, it looks best to colour the line art also.

STEP 13

Next, merge all outfit layers. To do this exclude skin tones, overlays (and perhaps hair, eyes, lips and bows colours) and create a new colour version quickly by editing multiple outfit parts in one hit. In this case I've changed to a blue Sweet Lolita colour scheme by adjusting the Hue level to −160.

ADDING A PHOTO BACKGROUND

Just dropping a photo into a piece of character artwork doesn't usually add a lot to the overall piece – it can overcomplicate and detract from the figure and illustrative elements. To integrate photos into an illustration, consider correcting the positioning and making sure the perspective used in the photo matches the artwork. If you blur the image, creating just a suggestion of background, it will make the character a focal point and stop the photo from looking out of place against the artwork style.

Try tweaking the colours and contrast. High contrast helps to create a more abstract, suggestive background. The photo's tones should mimic or complement the illustration.

STEP 14

Take or source an appropriate photo; in this case, I've used a Tokyo street.

Copy it to the Lolita art and name its layer 'Photo'. Use the Crop tool to enlarge the canvas to an appropriate size. You can also go to Image –> Canvas size and type in specific new dimensions. Position the background so that it fits with the character perspective.

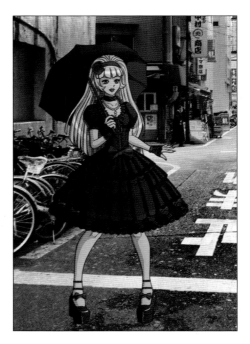

STEP 15

With the Photo layer selected, go to Filter –> Blur –> Gaussian Blur. Set the blurring to 20 and click OK. To blur out distant objects even more, use the Square Marquee tool, setting its feathering to 600 pixels via the tool options bar. Create a selection covering the top two-thirds of the canvas. Add a second Gaussian Blur set to 40.

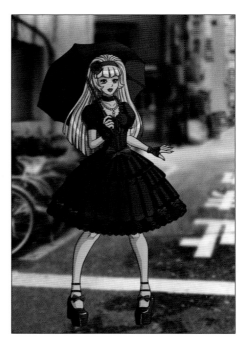

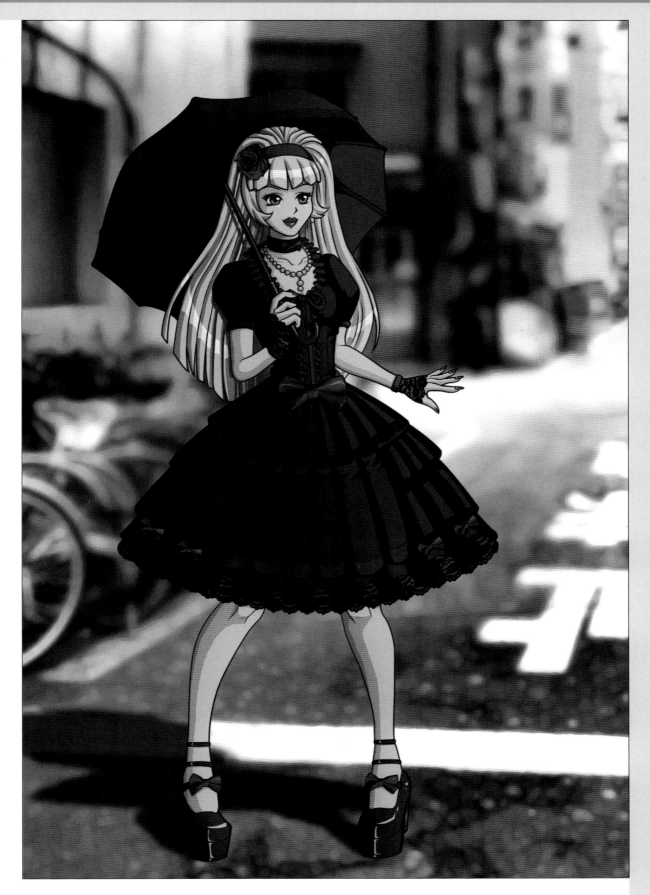

STEP 16

Increase the background contrast, add a shadow layer to the ground and add any additional overlay tones. Once all visible layers have been merged [Shift+Ctrl+E / Shift+Cmd+E], play around with adjustments such as Color Balance, Hue/Saturation, Variations and Curves – this can be a lot of fun and will give your artwork a totally different look.

CHAPTER 11
BEASTS

Working on non-human characters can be a lot of fun. This chapter explains how to achieve different textures and effects using photographic overlays and a variety of custom brush types on monster designs, including an eye-catching mutant zombie, a terrifying werewolf and a serpent-headed Leviathan.

Mini-tutorials

▲ Adding colour

▲ Painting in a quick background

▲ Adding rain FX, fur textures, fire FX, scales, water FX

Rendering style

▲ Soft and semi-soft CG, working with Brushes

Internet

▲ Tutorial video and materials download: http://digitalmanga.organicmetal.co.uk

MUTANT ZOMBIE

Draw the kind of guy you might have to fight off in a survival horror video game. This is really just a case of drawing a front-view figure, then adding some wacky proportions and other mutating monstrous details.

STEP 1
Make a pencil drawing and scan it in to the computer. Adjust the Levels to get rid of paper grain and smudges and use the Eraser or a white brush to assist with deleting any unwanted marks. The line art for this one will not be vigorously cleaned up or digitally inked, as this is often not necessary with rough-textured monster designs.

STEP 2
First, lay down your flat tones (see pages 60–61).

STEP 3
With a central light source in mind, add soft shading and rendering to the character, bringing together all the shading techniques you have learnt in earlier chapters. Keep the skin and clothing fairly dull, as the intention is to make the bright, creepy eyes and tentacles pop out more. I set the Brush mode to 'Color' to add some pink to parts of the grey-green skin and blue to the tentacle tips.

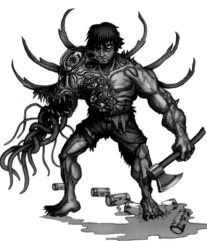

STEP 4
With dark subjects such as monsters, a dark background is required. Use the digital drawing method explained on pages 44–5 to add some suggestive background elements with blue lines – in this case, oil drums and barrels – nothing too detailed. Then, using the background painting method explained in Jake's tutorial (see page 98), paint in some tone shading. Select 'Thick Heavy' or 'Natural Media' brushes of various opacity and flow percentages for added texture. Lay the ground shadow underneath the monster.

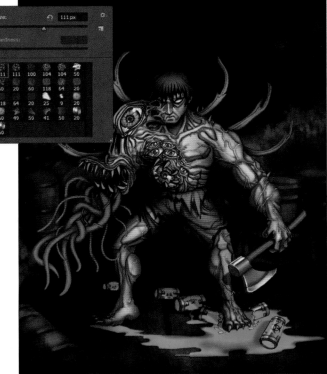

STEP 5
Now add some rain. Create a new layer on top in the Layers panel and name it 'Rain'. Fill it with black then go to Filter –> Noise –> Add Noise. Adjust the Amount slider to around 150%, check the Monochromatic box, then click OK.

STEP 6

Go to Filter –> Blur –> Motion Blur and set Distance to around 200 and Angle to 65.

Enlarge the content of this layer using the scale Transform to around 150% to lengthen the rain and get rid of edges created with the filter. Now set the Rain layer's blending mode to Screen. Use the Levels adjustment and/or Curves and Brightness/Contrast to achieve a fine layer of rain overlay.

The effect of wind means that rain does not always fall in a single direction. So duplicate the Step 5 process, but with a slightly different blur distance and angle. Then place this layer towards the bottom, behind the character and in front of the background.

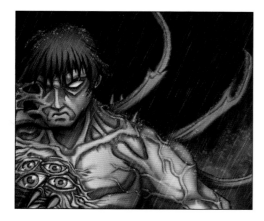

STEP 7

Where the rain hits surfaces, it causes splashes and drips. To create random splash dots, bring up the brush palette and select a small 5-pixels hard brush. Under 'Brush Tip shape' set Spacing to 750%. Under Scattering, check 'Both Axes', 1000% scatter, set Count to 3 and Count Jitter to 20%.

Now, on a new top layer, draw in the splash dots around the character's edge. You could paint these dots on to any surface facing the direction of rain, such as the barrel tops, bushes and ground, but keep them minimal or you will obscure too much of the character design and lighten the piece too much. Next, go to Filter –> Blur –> Gaussian Blur and set Blur Amount to 3.

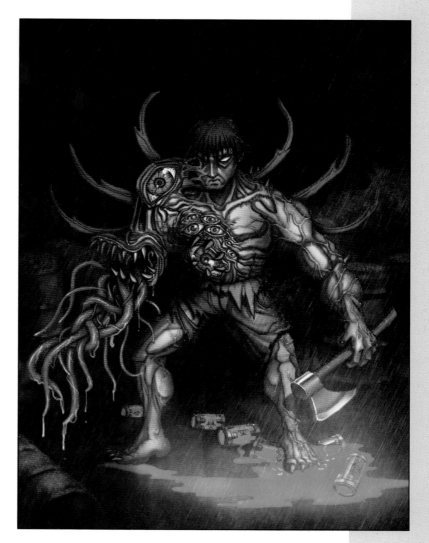

STEP 8

For the finishing touches, add saliva to the tentacles. Add a green Screen overlay for the ground slime and a red Overlay layer towards the left. Make final adjustments to hues, values and tones.

WEREWOLF

Draw a werewolf, using digital techniques to create fur and atmospheric details such as fire and smoke.

STEP 1
Start with a tablet-drawn Werewolf.

STEP 2
Lay down the flat tones. In this case they're very simple – just fur, eyes, claws and teeth.

STEP 3
Add a wave of semi-soft shading.

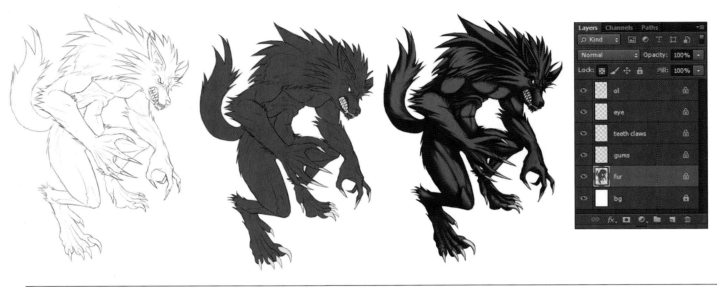

Fur: installing and using pre-made brushes
As with pattern files, it's possible to download and install pre-made Photoshop brushes. If you come across these, they will need to be downloaded and stored within the Photoshop Brushes directory on your computer hard drive. The hard drive directory to copy and paste downloaded .ABR brush files to is:

For Windows:
Program Files\Adobe\Adobe Photoshop CSX\Presets\Brushes\

For Mac OS:
Users/[user name]/Library/Application Support/Adobe/Adobe Photoshop CS6/Presets/Brushes
Download some brush examples – visiting this Deviant Art link http://fav.me/d4gzf9o will give you a nice selection of wildlife texture brushes. Restart Photoshop and the brushes will now be selectable via the Brush options bar at the top.

The possibilities when working with custom brushes are endless – I could devote another 160 pages to demonstrating the application and creation of different custom brush types in digital art.

STEP 4
With a selection of new brushes installed in the appropriate directory, add them to the Photoshop workspace by clicking the small cog icon in the top right of the Brush palette and selecting Fur Brushes.

Open a new canvas and experiment with the brushes to see how they work in practice.

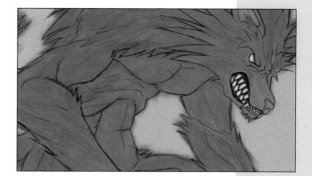

STEP 5

Return to the Werewolf image and create a new layer above the Fur shadow layer named 'FurTexture'. Select an appropriate brush and apply fur using black and brown tones. Temporarily hiding the Fur shadow layer may make it easier to see where the new fur texture is being added. Keep the direction of fur consistent, as you would find on a cat or dog, following the body's form and muscle tone. Refine the fur and remove blotchiness by selecting a smaller brush size and creating a series of short grey brush strokes over the top.

STEP 6

Set the FurTexture layer blending mode to Vivid light. Duplicate the layer. Set the duplicate layers blending mode to Hard Light. This will create more contrast as these layers overlay the original Fur shadow layer beneath.

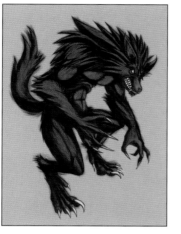

STEP 7

Make final adjustments to the character. Replace the colour of the darkest shadows and set them to a less saturated blue tone; adjust the contrast; clean up excess texture using the Eraser tool; colour parts of the line art; add a little more shadow under the arm and neck with a purple colour and brush set to Multiply; and create the ground shadow.

FIRE AND SMOKE

You can add fire and smoke to illustrations by using manipulated Photoshop filters or custom brushes or, probably the easiest way, adding stock photos from the internet.

STEP 8

To make the image more interesting, add a fire effect to the right side of the wolf. Insert a stock fire or flame photo, resize it to fit, then set its blending mode to Screen. The darker the character or background behind the fire, the more the flames will stand out.

STEP 9

To increase the amount of fire, add additional photos of flames of different sizes. A smoke image can also be added using the same process. The smoke can be inverted Image –> Adjustments –> Invert [Ctrl+I / Cmd+I], then set that layer to Multiply mode rather than Screen for dark smoke rather than light.

Finish by adding an orange overlay layer to the left-hand parts of the werewolf to denote glow from the fire. Darken the background, and after merging all visible layers, tweak the colour balance and levels to achieve the desired effect.

LEVIATHAN

Draw a mythical sea creature, using digital techniques to add scaly skin, monstrous ocean waves and an otherworldly glow.

STEP 1
Start with a pencil-drawn Leviathan, a water-based, dragon-like creature. The idea is to situate him in water once he is coloured.

STEP 2
Lay the flat tones. I've alternated the front body scales on two separate layers as I want them to be slightly different colours. This can also help with shading.

STEP 3
Add a soft shading to each layer.

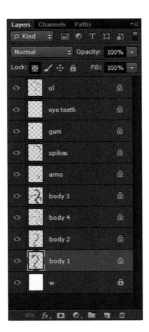

Scales using pre-made brushes
Scales can be added with custom Brushes – see the Werewolf tutorial on page 130 for instructions on how to install and use Brushes. Alternatively, they can be added using photographic textured overlays. Sometimes scales covering the entirety of an area are not necessary and an indication placed in the right position is enough to illustrate a scaled surface.

STEP 4
Add a selection of installed Scale brushes to the Brush palette.

As with the fur tutorial, open a new canvas and experiment with the brushes to see how they work in practice, then return to the Leviathan image.

STEP 5
Create a new layer on top of the rear body layer and name it 'Scales'. Select an appropriate brush size and white foreground colour then, starting from the head and working down, draw a line of scales following the shape of the body. A second or third line may be needed, depending on the size of the brush. When adding scales, as with fur, make sure they follow the same direction; check out a photo of a fish to make sure the direction is correct.

STEP 6

Create additional layers and repeat step 5 to add scales to other parts of the Leviathan. Use different scale brush types as necessary. Set the blending mode of these scale layers to 'Overlay'.

STEP 7

Another way to create scale-like texture is to use Cuts. To do this, create a collection of small circular selections with the Lasso tool on the face. Then, on a new layer, use a soft brush with white to dust over the selections. Deselect [Ctrl+D / Cmd+D], then set this layer's mode to Overlay.

STEP 8

Next, add water. Enlarge the canvas, particularly at the bottom, to make way for the water layers. Create a layer at the top of the Layers panel named 'Water'. This will be used to cover up the messy excess on the bottom portions of the body. Replace the white background at the bottom with a second Water layer – use a slightly lighter blue tone and brush to fill up the bottom two-thirds of the image. Create a layer beneath at the bottom and name it 'Sky'. Fill the Sky layer with a lighter blue tone.

Install custom water brushes and use these with white as the foreground colour to build up overlapping splash effects. Sometimes it's a good idea to place each splash like a stamp on its own layer. This allows it to be tweaked and transformed independently before being merged with the Water layer below. Try mixing different splash brush types, angles, sizes and opacities.

STEP 9

Source an appropriate image for the sky, in this case clouds, and add it to the sky layer at the bottom. Perform the usual adjustments to make it fit and blur it out. Remember water often reflects the same colour as the sky, so, for example, a purple sky means adding purple tone to the water colour to match.

STEP 10

Now make your final touches. Adjust Contrast; add a little more shadow to the Leviathan using black on a layer set to Multiply; add an inner orange glow; and add orange overlay layers to give focus towards the face and add contrast against the purple sky.

CHAPTER 12
DOS, DON'TS AND ART ON THE WEB

For anyone learning to create digital art, it's often the case that the same obstacles present themselves time and again. Instead of tackling those obstacles, newbies may try to rush the process of creating artwork and leave it looking far less accomplished than it should. However, I hope that by now you will understand what it takes to create characters and rendering to a professional level. In this chapter I've highlighted a few common mistakes you need to avoid and given reminders of techniques that will make your artwork even more successful.

Chapter highlights

▲ Common pitfalls explained

▲ How to create an efficient workflow

▲ Art on the web and online
 considerations

▲ Additional advice

COMMON PITFALLS

When they first set out on their digital journey, some aspiring artists assume that computer software will do the work for them and compensate for a lack of basic drawing and painting skills. That's what I assumed, too! In many areas I believe it's fair enough to use a computer process to cut corners. I wouldn't call it cheating provided you're not telling people you have manually painted individual details when in reality you have used a custom brush or pattern overlay to do a lot of that work for you. However, working digitally is not an excuse to be lazy with your art, nor is it a way of escaping the amount of time and effort it takes to develop general drawing and painting techniques concerning proportions, perspective, light, shadows and composition.

Practice makes perfect

No matter what level you're at, it's great to see any aspiring artist giving it a go and having some fun experimenting with digital art. Over the years I've seen hundreds of novice digital artists present samples of their work. Understandably, first attempts usually need a lot more attention. Here are some examples of what can go wrong.

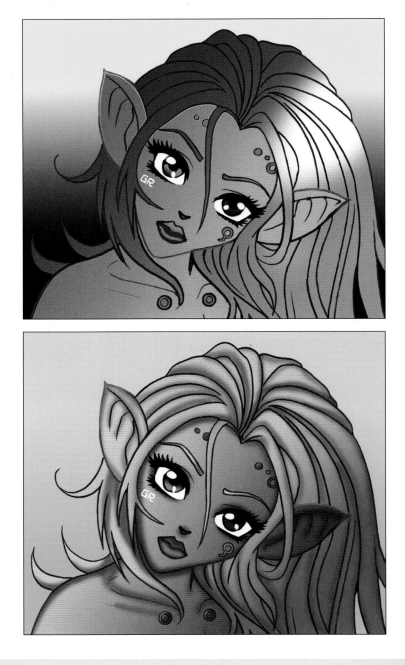

Attempt 1

This one has a lot of problems. The initial flats were not all placed up to the edges of the lines – notice where the skin meets the outline. During the flatting process, double check that you have expanded all selections by 3–10 pixels before filling in with a colour, especially when you're working with light colours on a white background.

There is a light source here from right to left, but it's much too subtle, especially on the skin tone. The aim is to show form – that the head is round and not flat and that overlapping or raised elements cast shadows. The hair is simply a light to dark grey uniform gradient with a blob of white highlight – this should be manually shaded with a range of values and tones for each section of hair. When shading lips, the top lip should be darker than the bottom, and the highlights in both eyes should be reflecting light coming from the same direction. The background is muddy; mixing black into light colours such as yellow doesn't help.

Attempt 2

This is looking better now that the previous problems have been resolved, but it's still bland and uninspired. While simply adding darker shading around each line helps, it looks a little messy and rushed. Using a lower-flow, soft brush would enable these lines to be blended out so that they appear less blotchy. To make the work jump out, it needs more contrast and tonal range as well as details such as shine on the hair and skin and shading in the irises of the eyes – arguably the most crucial part of any figure.

Attempt 3

This is more like it!
The previous skin
and hair tones have
been neatened up
and blended out to
give a softer look.
The eyes are now
more detailed.
Shapes have
been added to the
background to stop
it looking flat
and plain.

Attempt 4

Finally, some extra cast
shadows and a few
colour overlays have
been added. The skin
tones in the previous
attempt look nice and
might be to your taste,
but I like a high-contrast
effect such as the one
here as it creates more
impact and has a glossy
look to it. If you've
followed the tutorials
set out in this book, the
mistakes in the first few
attempts here should
be avoided entirely
and reaching the goal
of producing fantastic,
professional-standard
digital artwork will be
much easier.

TROUBLESHOOTING

If you've followed the book this far, you'll know what to do when using Photoshop. However, there are a few points, including the misuse of Photoshop tools, that are worth taking a further look at.

Dodge and burn

Some new artists try to rely on these tools for everything. While they have their place, Dodge often leaves artwork looking washed out, while Burn tends to make colours appear muddy.

Lens flare

Located within the Render category, this filter is often wrongly used to give a glow effect. It doesn't have a place in digital artwork.

The overuse of filters

While Photoshop has many effective filters that can be applied to artwork, they should be used for a specific purpose and to achieve a certain look. If they are overdone, they are distracting and the image can look tacky.

Up-scaling

Once you've created your artwork you will be unable to increase its size without losing quality. Make sure you start out using the largest possible image dimensions your computer can comfortably handle.

Lazy/rushed inking

This can spoil an otherwise great design. Common mistakes include lines that should be parallel but aren't, lines that do not meet at the ends where they should, and lines that wobble. An unvarying line weight is another problem – typically, fiddly details should use a thinner line, while bold shapes, outlines or objects closer to the viewer look best with thicker lines. Lines that do not connect to other lines should often taper to a point for best results. Drawing with wide, sweeping motions often helps to eliminate a lot of inking errors.

Unsuitable backgrounds

A great character illustration can be let down by a poor background. Sometimes a full-on, detailed background isn't required, but if you're using a colour, pattern or tone instead of white, make sure it complements the character and existing colours used. Stay away from garish colours like flat red or saturated green and don't resort to using cheap-looking patterns of stars, circles or clip art for a background. If you're creating an illustrative background to give some kind of context to the character, spend some time on it and try to make it look as awesome as your character art. Remember to add shadow to the ground to stop your character looking as though he or she is floating.

Misuse of the gradient fill tool

The Gradient Fill tool is sometimes used instead of a brush to create shading, as seen in Attempt 1 opposite. The Gradient Fill is great for enhancing artwork by creating overlay gradations, but it is not a substitute for manually placing shadows with a brush.

Jagged strokes

When using a hard brush, minimize brush spacing from the default 25% to 1% to avoid jagged strokes, if moving the pen slowly on a graphics tablet.

Impatience

This is the reason why so much of the artwork on the internet doesn't live up to its potential. You don't need to invest 100 hours in making a sketch perfect, and I certainly don't advocate putting in so much time and effort on an artwork that you stop enjoying the process. However, if your portfolio of best works consists of images that were created in an hour or two or demonstrates that you weren't willing to put in the time to correct mistakes or learn appropriate techniques to get the job done, then you're doing yourself a disservice. Art is very much like working out – you won't get the amazing body you wish for if you're only willing to do the bare minimum. Sculpting a physique takes continual effort over a long period of time, and it's exactly the same for drawing and painting. Don't be put off by the first hurdle, or even the tenth hurdle! Learning new software and becoming the amazing artist of your dreams is something that is going to require hours of work, but the end result will be worth it and the journey can be a lot of fun too.

Loss of work

It's obviously necessary to save your work regularly, but it's not uncommon for people to get so engrossed in their artwork that they forget to do so. You never know when Photoshop might crash or some other operating system error might occur. You could even experience a power cut. It's also worth backing up your Photoshop art files on a separate drive or location in case of hard disk failure. CS6 features a customizable auto-save feature: setting auto-save to every 5 minutes may help to recover your latest work after a software crash.

When it comes to digital art, if you rush things and aren't interested in learning and improving you'll be stuck producing artwork you're not happy with. Always take the trouble to go back and fix things you know aren't right rather than settling for 'it'll do'.

HOW TO SUCCEED

There are some common mistakes that inexperienced digital artists make. Some of these errors can be avoided by being prepared, organizing your work carefully, keeping your workspace tidy, labelling files clearly, grouping layers and becoming familiar with the range of keyboard shortcuts.

Be efficient

If you're someone who is disorganized, working surrounded by clutter and leaving unlabelled files dotted around, that's fine provided you really work best that way. Otherwise I recommend keeping your physical and digital workspaces tidy. Label all your files so that they're easily identifiable and keep them in properly named and easy-to-locate directories. Give individual Photoshop layers names, especially if there are a lot of layers to keep track of. Customize the workspace so that you know how to quickly access every tool, palette and process, and learn as many useful shortcut keys as possible. The idea is to spend a little organization and preparation time at the outset, thereby saving a lot of time over the course of your digital art projects.

Group layers

If you have more than seven or eight layers, consider grouping them (Cmd+G). Alternatively, select multiple layers on the Layers panel then click the small menu icon at top right and select 'New Group from Layers'. Name your layer group, for example 'Character Elements', and optionally select a colour for your group before clicking OK. The example on the right shows how grouping and colour coding can work:

▲ 'Character composite' is on a regular layer of its own at the top
▲ Overlay layers are contained inside a red group called 'Overlays'
▲ Beneath those are several character-related layers in a yellow group called 'Character Elements'. This folder has been closed by clicking the small arrow next to the eye icon. Closing a group allows you to tidy up the Layer palette.
▲ Background-related items are placed in the 'Background Elements' group
▲ A regular layer outside any group has been coloured-coded by right-clicking it and selecting blue

Use the Eye icon to hide or reveal all layers contained within a group. These groups can be repositioned in the layer order without manually moving each individual layer.

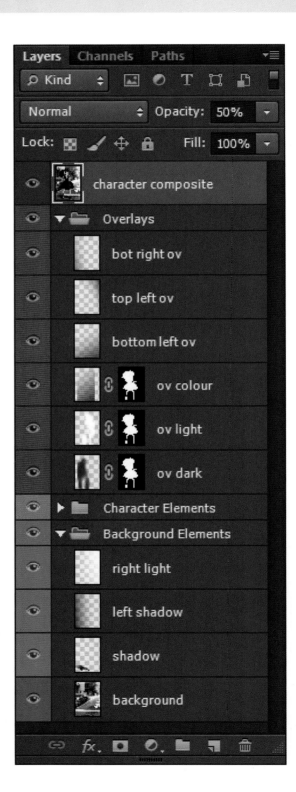

Use keyboard shortcuts

Once you are accustomed to the Photoshop user interface it is vital to learn at least some of the shortcut keys to increase efficiency and aid workflow. I have mentioned many of the important ones throughout the book. My personal favourites include:

Navigation

Ctrl + + / Cmd + + = Zoom in
Ctrl + - / Cmd + - = Zoom out (zooming in and out can also be achieved with the mouse wheel)
Spacebar = Hand tool to navigate around a zoomed-in canvas
R = Rotates Canvas View – great for helping to draw freehand curves
Tab = Show/Hide all panels

Painting and colouring

S = the Stamp tool, by default; I recommend setting it to Smudge tool in keyboard preferences
E = Eraser; I also like to assign this to my tablet pen button – the one closest to the tip
G = Gradient tool; I find it's easier to use this than Paint Bucket to fill
P = Pen tool, for digital inking
B = Brush
[= decreases brush size
] = increases brush size
Alt / Opt while brush selected = Eyedropper
X = alternates between foreground and background colours
Shift + number keys while brush selected = adjust flow percentage

Selections

W = Magic Wand, for selecting pixels based on tone and colour
M = Marquee tool (hold down Shift to constrain the proportions of the marquee)
Shift + M = Drag, to constrain selection to square or circle
L = Lasso
Shift while pressing L = cycles through Lasso tool types
Any selection tool + Shift = add to selection
Any selection tool + Alt / Opt = subtract from selection
Ctrl + A / Cmd + A = select all objects on a layer
Ctrl + D / Cmd + D = deselect all objects on a layer
Shift + Ctrl + I / Shift + Cmd + I = invert selection/s
Ctrl / Cmd + click layer thumbnail = load layer transparency as a selection
Ctrl + Shift / Cmd + Shift + click another layer thumbnail = add to current selection
Ctrl + Alt / Cmd + Opt + click another layer thumbnail = subtract from current selection

Manipulating content and layers

V = Move tool
Ctrl + T / Cmd + T = transform your object, which includes resizing and rotating
Shift + Ctrl + N / Shift + Cmd + N = create a new layer
Ctrl + G / Cmd + G = group selected layers
Highlight specific layers then Ctrl / Cmd + E = merge layers
Ctrl + E / Cmd + E = merge and flatten selected layers
Ctrl + Shift + E / Cmd + Shift + E = merge visible layers

Adjustments

Ctrl + L / Cmd + L = levels
Ctrl + B / Cmd + B = by default, this is the colour balance, but I recommend setting it to Brightness/Contrast as it's used more often
Ctrl + H / Cmd + H = by default, this hides/shows Extras; I recommend setting it to Hue/Saturation as it's used more often

Miscellaneous frequently used

C = crop; enlarge the canvas by cropping outside the canvas boundaries
T = type; to add text

Saving

Ctrl + Shift + S / Cmd + Shift + S = save your work as
Ctrl + Shift + Alt + S / Cmd + Shift + Opt + S = save for web and devices

EXPERIMENT WITH OTHER SOFTWARE AND MEDIA

Manga Studio, Sketchbook Pro, Paint Tool Sai, Gimp and Corel Painter – to name just a few art programs – all have their pros and cons. I've used a number of different programs in the past and I recommend Adobe Illustrator for inking, as it has an auto-smooth feature when drawing lines, and the vectors art it creates can be output to any dimensions that are required. Sai (for Windows) is also becoming popular for drawing and sketching – it requires less computer processing power and has fewer features, making it easier to use out of the box. Digital art, and art in general, are about personal preference, so find the tools that work best for you.

But Photoshop is *the* tool for professionals. I struggle to find a good reason to use anything other than Photoshop CS6 for my work. While other programs have a feature or two that Photoshop lacks, it makes up for this with dozens of useful and unique features of its own along with a huge selection of filters, blending and adjustment modes and a massive library of resources, such as online tutorials, custom brushes and patterns.

Getting to grips with Photoshop also makes diversifying into photography, graphic design, web design or video game design so much easier. I've worked exclusively as a web designer for a number of years and wouldn't have had that opportunity had I not already been familiar with how to create Photoshop artwork.

Use reference
If you don't know how to draw, colour or shade something, see how other artists have tackled the same subject, or use your own photos. Save images to your computer or build an online directory of useful reference images, from flowers to scenery, man-made objects, people, animals, lighting effects and so on.

Things to remember
If you check out the accompanying time-lapse videos for many of the tutorials in this book, you'll notice that despite the fact that each image I create is quite different and requires different approaches, I repeat many of the same procedures. A few of these include:

Zooming
Remember to zoom in when drawing details. Line art can look OK when viewed at a zoomed-out state, but it's only when you zoom in closer that you realize certain lines are wobbly or that there are tiny gaps in the colouring (especially in narrow portions of line art where a Magic Wand tool might not reach).

Brush sizes
Change brush sizes frequently throughout the project, using large brushes for open areas and smaller ones for tight areas or when concentrating on details such as the face and eyes. Photoshop's Basic Brushes are great for both a hard-shadow cel style or soft airbrush style.

Duplicate layers for experimentation
If you want to test out an effect, shadow placement or colour adjustment, it's a good idea to create a duplicate of any given layer. Make sure the duplicate is positioned on top of the original layer in the Layers panel. You can then experiment on the duplicate without messing up the original layer. Also, if you feel any of the new colours or tones applied to the duplicate layer look good but are too strong, adjust the opacity of that layer to tone it down and effectively mix it into the layer beneath. These layers can then be merged together if necessary.

Effects
These can be achieved using Photoshop's filters, brush or tool option blending modes, layer blending modes, layer styles and image adjustments. Play around with all these before starting anything serious, or indeed during or after you've completed artwork, to test out the many variations and unique custom looks you can create. I experiment with different effects every time I create a new piece of artwork. It can be a lot of fun to see if it's possible to make artworks more striking and effective by tweaking them with a series of effects and adjustments.

Finishing touches
With each completed image, you must decide if you want to add a border, text or decorative effects. To add a simple border, use the Crop tool to expand the image size outside the canvas boundaries or go to Image –> Canvas Size and input an appropriate increased value. Use the Rectangle Marquee tool to create a selection where you want the border to be. Invert the selection and, on a new layer at the top, fill it with black. You can then lock the transparent pixels of this layer and perhaps apply a gradient effect or a layer style such as Inner Glow. Also consider if you wish to sign your work. If so, place a small signature in the bottom corner where it does not interfere with the piece.

Be patient, learn from and fix your mistakes and make the most of the digital process to reap the rewards.

ART ON THE WEB

The internet has revolutionized how we live our lives and how we conduct our artistic endeavours. It's now easier than ever to seek out online tutorials and resources, post your work for feedback, collaborate with other artists or just show off what you can do in your own personal website or portfolio.

Sharing art online

Once an artwork has been completed, it needs to be saved at smaller dimensions to fit on web pages and decrease its file size (see page 27). It's important to bear in mind that different screens display images at different resolutions and sizes. An image might look small on a high-definition 1920 x 1080 pixel resolution monitor, but it might be too big to fit within the screen width on older systems or handheld devices which may run at a resolution of 720 x 1280 pixels, for example.

I recommend saving web images with image pixel widths no bigger than 1000–1500 pixels at 72 dpi and aiming to save a file size of 200–400KB by adjusting the output image quality. The bigger the file size, the longer it takes to download.

When images are resized, image quality can suffer. Even when down-scaling, image clarity can be lost, as Photoshop translates a larger amount of pixel data into a smaller area. By default, resizing with CS6 will auto-sharpen an image when it is scaled down; this can sometimes result in over-sharpening. When resizing via the Image –> Image Size options box, click the drop-down menu and change the resample mode at the bottom from Bicubic Automatic to Bicubic before clicking OK. You can then control how much the resized image is sharpened by going to Filter –> Sharpen –> Unsharp Mask and toggling the sliders until you reach a desired amount of sharpening. You can also permanently adjust the default Image Size resampling method via Preferences, in the General tab heading.

Image copyright

Artists hold copyright in their original work, so that it's illegal for anyone else to publish it on the web or in print. This doesn't mean that when you put your work online no one will take your image and use it. As far as my own work is concerned, I think it's fine for people to use it for personal, non-profit projects, but I like to know where the image is being used and expect a credit for its creation.

Limiting image dimensions and dpi size stops art thieves from producing high-quality prints then profiting from your artwork. It's a good idea to add copyright information and your contact details or web address to every work you publish on the internet.

Art communities

Web-worthy jpegs (or gifs and pngs) can be emailed to friends, uploaded to social networking sites or shared with art communities. There are many great art sites and communities where you can set up a profile, create a gallery and interact with fellow members by commenting on their art, blogs or forum posts and responding when they do the same with yours.

I've been a member of DeviantArt for many years. With currently well over 25 million members, it's the biggest art-based social networking site around. Spending time in an art community can be really inspiring – with so many different artists from around the globe, it's a great way to find out what's going on in the art world and receive constructive criticism from fellow artists. Admittedly any type of criticism can be hard to take at times, but if you can gain new insights and learn from it, your next attempts will be better and better. Alternatives to DeviantArt include www.elfwood.com; www.

sheezyart.com; www.shadowness.com; www.
artwanted.com; www.artgrounds.com; and
www.worth1000.com.

Building your profile

The following points cover ways to set about
building an online profile.

Give

Comment on other people's artwork, give their
works a 'like' or 'favourite' or add them to your
friends or watch list, and they may do the same
in return.

Be involved

Contribute to forum posts and post blogs of your
own, collaborate with other artists and join or create
relevant groups. Get to a point where members
recognize your name, website avatar and artwork.

Create a gallery

Quantity and quality are important. Create a
gallery which people will take time to enjoy
browsing through.

Be nice

Have fun and enjoy your online experience while
being considerate and courteous to other members
who may read what you write. In my experience, art
sites are full of great people and there seem to be
very few instances of internet trolls bad-mouthing
other artists or their work.

Other web opportunities

A good way to get your art out there is to set up
your own blog – Blogger.com and Wordpress
provide great free blog accounts. Tumblr also allows
you to build a page and post your images with ease.
Consider creating a Facebook page or just sharing
your art with friends on a regular Facebook account,
or use image-hosting sites such as Flickr and
Photobucket to host your artworks.

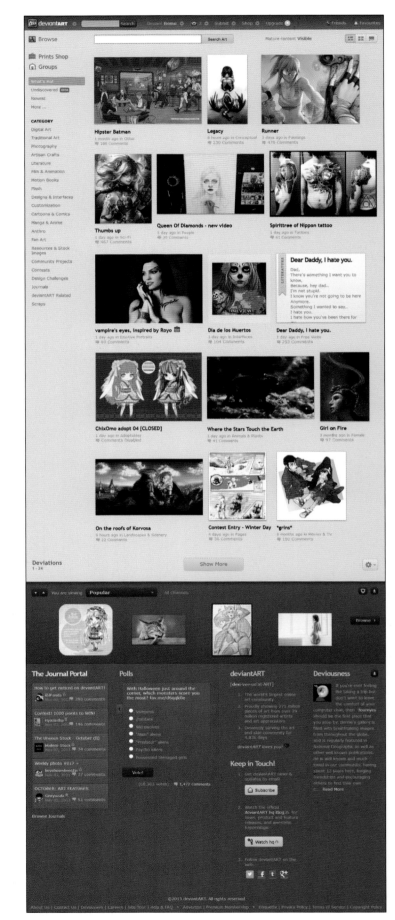

Displaying your portfolio

Having a dedicated website to showcase your best artwork is a must if you intend to work as a professional artist or designer. With the right marketing and SEO (search engine optimization) it can generate work, demonstrating to prospective employers and clients what you can do. A PDF portfolio is also useful for attaching to emails or printing off and showing to the right people. You can pay a designer to set this up for you, or you can learn to design and create your own website and portfolio.

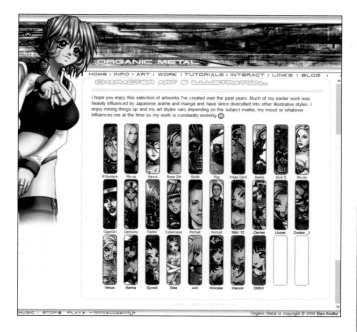

Using Adobe Bridge (which comes bundled with Photoshop), it is possible to create a PDF portfolio. Open Bridge and navigate to the folder containing your artwork. Select your ten best works by clicking each thumbnail while holding Ctrl / Cmd. At the top right, click the Output tab, then via the right information panel choose PDF rather than Web Gallery. From here it's a case of filling in the relevant details before clicking Save, and Bridge will then generate the PDF file.

Collaborations

It's now possible to join forces in creating art projects and illustrations with anyone in the world. Mock ups and drafts can be shared on sites such as Google Drive and DeviantArt's Sta.sh site.

Try to work with people of the same skill level. If you are paying other team members, keep in mind that their fees will often reflect their ability. You and your collaborators should be able to:

▲ Speak the same language
▲ Agree on a brief or objective
▲ Understand what's expected of you and the rest of your team
▲ Provide your/their share within a deadline or reasonable time scale
▲ Produce work to a suitable standard
▲ Communicate any issues – if things aren't working as they should, let people in the team know instead of keeping quiet
▲ Give credit to collaborators

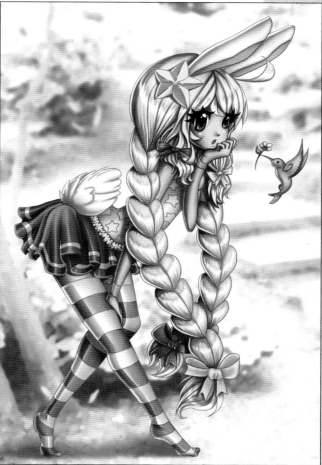

'Cotton' was originally designed by Deviantartist Midna01, adopted and drawn by Yioi, then coloured by me.

CHAPTER 13
FINISHED WORKS

This final section shows some of my finished works together with those of other established manga artists. Hopefully it contains inspirational images which demonstrate the range of techniques and details that you can incorporate in your own art. As well as studying the following pages, it's advisable to build your own library of favourite artworks as reference to help you achieve your desired style. The most important thing is to have fun and enjoy the process of learning and growing as an artist. I hope *Digital Manga* has provided you with the tools you need to create your own individual, incredible manga-style artworks.

Zombie love

This is my part of an 'art trade', where two artists agree to draw each other's original character for fun. This is manga artist Nayume's character. Apparently Nayume has a fear of zombies, so I thought it would be cool to have one creeping up behind her. Perhaps he's in love with her . . . or in love with her brain!

Happy Halloween

This character was originally drawn for an anime calendar. The artwork needed to feature a babe, something to do with the chosen month (October), and the theme 'Journeys'. I decided to go for a modern-Gothic witch girl, for Halloween. The background was drawn and added separately (see pages 98–9)

Sosuke Yong Kim

I wanted to create a character who can kick some butt as well as being someone I can relate to – an artist! This Japanese-Korean character has a lot of frustrations in life and vents his feelings through fighting (of course!) and his art, using a variety of media to get the job done.

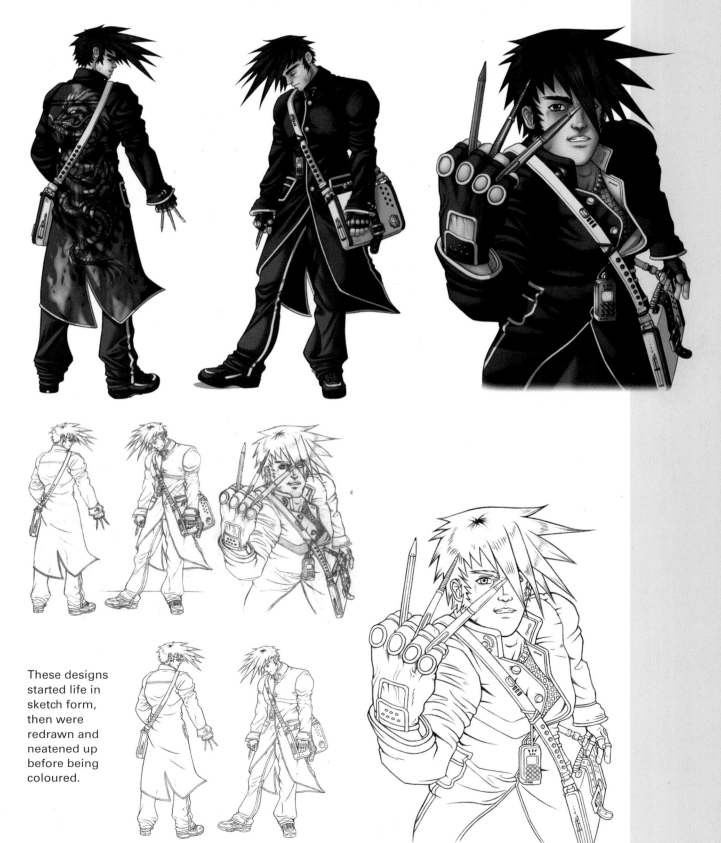

These designs started life in sketch form, then were redrawn and neatened up before being coloured.

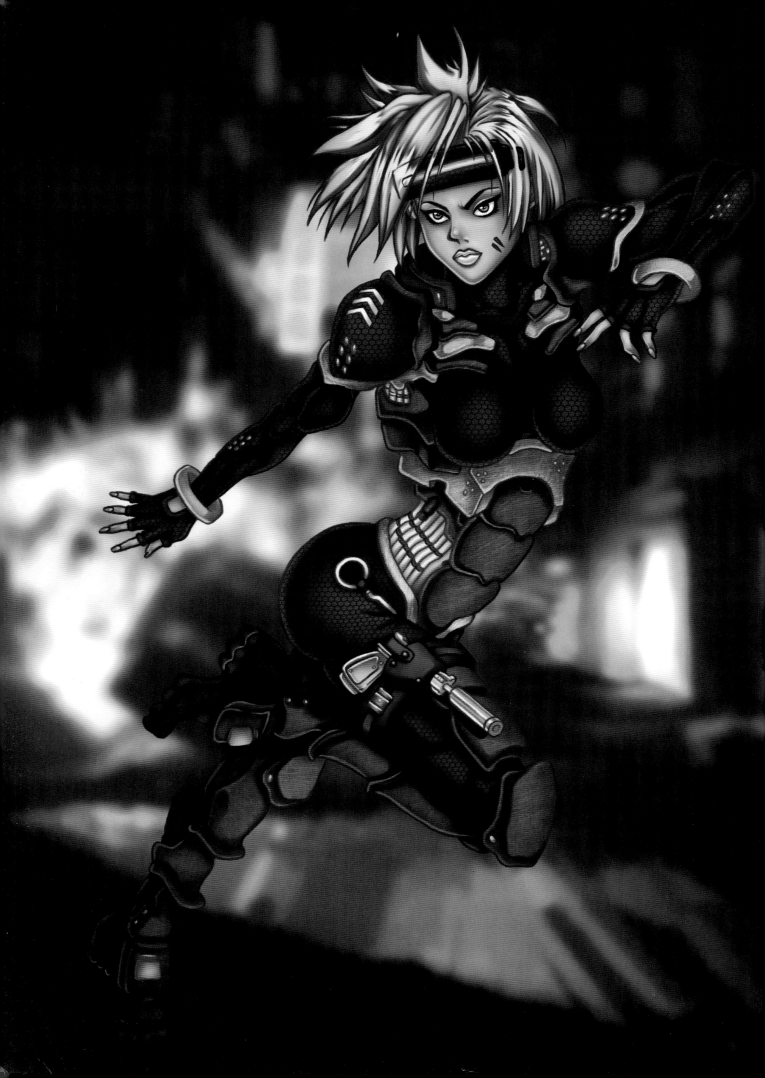

Cyber police

On the left is Natsumi, rising star of the Japanese cyborg police force. She fights in the future against bad-ass cyber criminals and monsters alike! Perhaps she lives in the same time period as one of my previous characters, Bengosha (see page 82). She's a cyborg with a body designed for speed and endurance.

Eternal Descent

Drawing backgrounds adds context to characters and can make a massive difference. These three artworks were created for the album *Losing Faith* by the heavy metal band Eternal Descent, and represent city scenes from the album's narratives. They were used in packaging and animated on an interactive website.

Gynoid

This female humanoid robot was initially inspired by the original manga android Astro Boy. I especially based the hair on this and I love Tron-style neon trim, so I had to get a bit of that in there too! I wanted her hair and skin to look like plastic, which was a little different, and I added in some colour effect at the end, such as the orange glow.

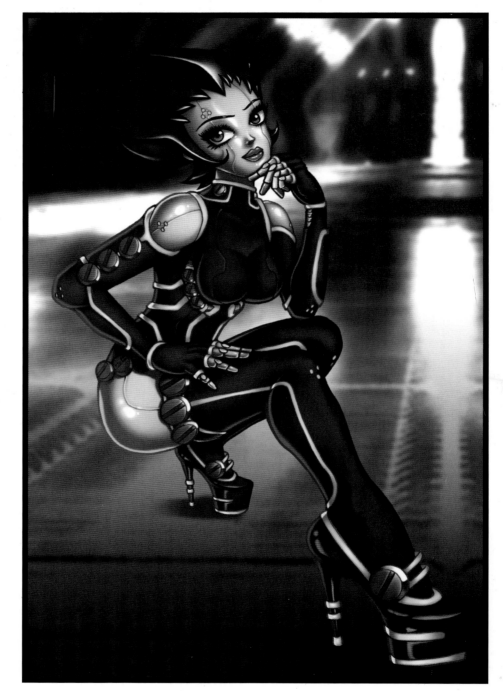

Fire-fighting femme fatale

This character was created for a client interested in seeing his glamorous *Strike Force* action ladies take a manga form. My usual process is to send an initial pencil drawing draft to the client. This is either approved or marked for revision. After the revision is approved, I'll have it digitally inked. The final aim is to bring it to a new level with Photoshop colouring.

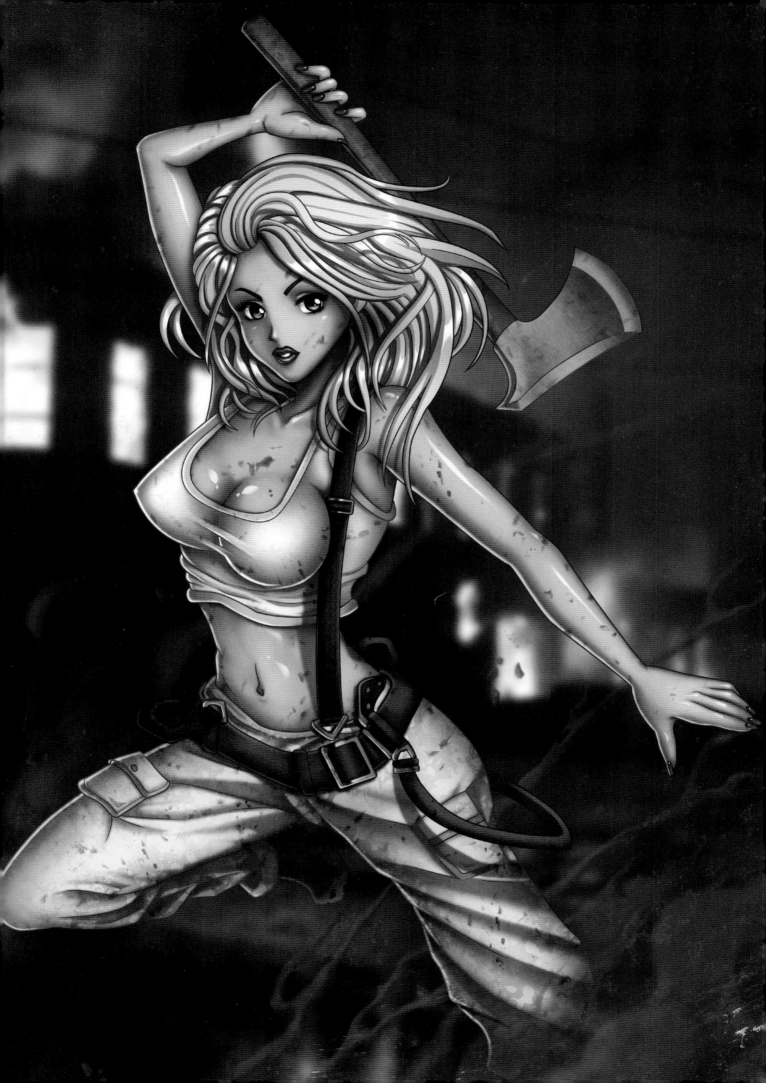

TIPS FROM INTERNATIONAL ARTISTS

Here are insights and advice from some of today's hottest international manga-influenced digital artists.

Edwin Huang (USA)

www.edwinhuang.com
http://edwinhuang.deviantart.com

'The most important tip I can give when designing characters is to soak up inspiration from everywhere and everything. Every character I have designed is a concoction of existing designs twisted to my own style and taste. Keep in mind that there is a huge difference between drawing inspiration from existing work and stealing ideas.

'I make my digitally coloured images look most effective when I make a conscious effort not to be timid with the tablet pen. Starting off with broad, confident strokes always leads to the best foundation digital pieces.

'The biggest problem I have with digital art is scaling. I don't zoom out often enough to see the whole picture; I have a habit of getting too detail-oriented way too quick. With traditional work, I can survey the whole workspace constantly, but with digital I fixate on what's in front of me. Keep in mind that the overall composition is more important than the little details!'

LET BLOOD RUN
illustration by edwin huang
caitlyn x camellia

Inma R (Spain)

http://inma.deviantart.com

'Learn the basics (layers, layer settings, brushes) and then be creative about the way you use them. Once you know how the basics work, you can create your own style, or mix what you learn from one place with what you learn from another. Tutorials are super-helpful, especially if you can apply that knowledge to your artwork.'

ShinRyuShou (Malaysia)

http://shinryushou.deviantart.com

'Every character created by an author/ artist must have its own storyline/history which establishes its personality. From there I start to imagine what the character would look like. The eyes and facial expressions tell you a lot about the character. Costume-wise, I try to keep it quite simple, as excessive decorations and accessories will only distract the

viewer's attention from the core personality of the character.

'I get most of my inspiration from music (mostly New Age or symphonies), movies, anime, novels, history books, or even the people I meet. Keep a sketchbook and simply sketch anything that catches your interest. You can then look over your drawings for inspiration whenever you start to draw a new character.'

Daniel Tiberius Salgo (USA)
http://danimation2001.deviantart.com
www.dandojo.com

'Draw! Draw as though each time you draw you get a +.005 to your score. Working with print is a lot different from just working for a digital project. If you work with a monitor that is too bright, your colour values will be really dark and will end up printing dark. You may want to adjust your monitor using a calibrator to make sure that your monitor is just right for print, then adjust it back for anything digital.

'Gather as many references as you can for designing characters. The more you have to work from the better.'

Natália (Brazil)
http://nataliadsw.deviantart.com

'Sometimes the character just shows up ready in my head and I just have to draw it, while other times I have to research what I want to draw. What pose do you want your character to be in? What kind of look do you want? Are they angry? Happy? Or are they just staring at the observer? Maybe they are looking at another character? The emotions are important, and don't forget about

the eyebrows! Then try to find the perfect hair, clothes and colours to match the atmosphere you want to portray. It's OK to look at the work of others for references, but you should give credit as to where your inspiration came from.

'As with any other media, digital art requires practice. You won't be the best artist the moment you start colouring digitally. You'll need a mouse or tablet and a good art program like Photoshop. I think that the Wacom tablets are the best. There are lots of different models to choose from, depending on your needs and how much money you want to spend. It can be very strange to use a tablet for the first time, but with practice and time you'll get used to it.'

Kimberley (UK)
http://kimmymanga.deviantart.com

'When creating a character, digital colouring can be a very useful tool. One very important aspect of making your character unique and able to stand out from the crowd is their colour scheme. Digital art is fantastic when it comes to picking the perfect colours, and with the aid of the handy Fill tool you can easily try out different looks to see what works best for your character. Once you've settled on colours you are happy with, you can add various little touches to really bring them to life, such as adding light blush to their cheeks and some shiny highlights to their hair.'

Brooke Stephenson (Japan)

http://ogawaburukku.deviantart.com

'For me and a few others, cel shading has always been the way to go – crisp colours and clear line art bring back the look of older animation promotional images. In order to keep this style fresh-looking, we've adopted new methods for an old favourite. One such method is incorporating gradation into the flat colours. Using Photoshop (CS5 for me), I colour inside my line art with flat colours, giving each colour its own separate layer, then locking each layer.

'I use the Eyedropper tool to pick the base colour then open the Colour Picker and select one colour diagonally to the upper left of the base colour. I click OK to set this lighter tone as the foreground colour.

'For the background, I choose one colour diagonally below and to the right of the base colour. I now have a lighter shade for my foreground colour and darker shade for my background colour. When combined, the difference will be subtle but effective.

'I select the Gradient tool and make sure the gradient option is set to 'foreground to background'. Rather than adding a gradient to the whole image, I use the Lasso tool to select areas of the image I want to add shading to individually. I adjust the gradation settings according to the body part.

'This is a very simple way to add a little extra "oomph" to your cel shading, and it's become a popular trick that even some animation companies are starting to use! Another simple trick is to do the same thing to the shadows of your character art. If you have the shadows on a separate layer with the Multiply or Linear and Color Burn filters on, you can then lock the layer and add a gradient to your shadows in the same way you applied the method above. Simple, but effective!'

Ein Lee (Taiwan)

http://einlee.deviantart.com

'It's helpful to think of a few words, themes, or motifs when starting work on a new character design. For example, 'energetic', a trait which might result in a character with short, spiky hair and vibrant clothing; or 'seafoam green', a colour which hints at a more calm, carefree character who might have long, wispy hair and simple clothes. Keep it simple. An iconic character design is one that doesn't get too bogged down with details, instead using effective combinations of colour and shape that convey the character's personality.

'Everything comes back to the basic principles of art – rhythm, contrast, balance, proportion, and so on. Using different values (light, bright shades offset by low-key neutrals), playing with negative space, and keeping a restricted palette (there's no need to use every colour of the rainbow) are sure-fire ways to keep an illustration interesting and easy on the eyes. Using these principles effectively comes with practice, I promise!'

Yuureikun (USA)

http://yuureikun.deviantart.com

'A lot of people ask me how hard it is making the jump from traditional art to working with digital media. There are a lot of different devices out there, and technology has made some really big and exciting advancements. For me, drawing on a traditional tablet was always too difficult. For those who rely on their hand-eye coordination while drawing, a pen display is the perfect solution. There are many models at different price points now, and they really help someone who is serious about going from drawing on paper to drawing on the computer make that transition.

'When it comes to developing your style, I find it best to look at all the different artists you love the most and take elements from all those different styles to compile them into something that is original and unique to you. It is always important to experiment and try new things with your style. To me, a style never truly settles in one place forever – it is a constant evolving thing.'

Poeyon (Japan)

http://poeyon.deviantart.com

'I observe and reference life before drawing backgrounds, characters and items. Even if I create fictitious art, I still base it on real-life objects and the more carefully I observe these objects, the better my work will end up.'

Adimas Soekidin (Indonesia)

http://domdozz.deviantart.com

'The first, crucial rule about making artwork in general is that you have to LOVE what you're doing. The moment you realize you don't love what you do, you'll be going nowhere.

'Identify yourself, find out what kind of movies, cartoons, animes, games and artists inspire you the most. Trust your intuition, it's always right. Then use them as your inspiration.

'Copy your favourite artist's work. The word 'copy' may be interpreted negatively, but don't worry – you can never copy their work entirely, nor will you lose your own style by copying them. On the contrary, it strengthens your style. Studying what colours they use and how they draw the character's eyes, body, armour, weapons and so on will boost your progress significantly.'

Kuridoki (Singapore)

http://kuridoki.deviantart.com

'Having trouble designing a character? If you're feeling stuck, you might want to look at the tools you're using. You'll be surprised by how many different outcomes you can get by changing your tools or your medium.

For example, if you've been painting digitally all the while, try to shake things up a little by working with traditional paint and brush or markers. Different tools will give your artwork a different character. Work loosely, getting the essential forms of the character you have in mind on paper, while putting less pressure on yourself to come up with a finished product on the first try (a common thing for many artists starting out).'

Heli Palmunen (Finland)

http://volvom.deviantart.com/

'Creating different characters is fun. Often the problem is that the artist can't decide which traits they want in their creation, ending up putting all their favourite things into one character, which can turn out chaotic. The easiest way to overcome this is to draw one character without clothing or any detail. Copy this figure a few times and try out different designs over each one, so you can easily see the outcomes and decide what looks good.'

GLOSSARY

Action lines Used in manga as multiple straight, parallel 'speed lines' to denote movement, or a circular arrangement of 'focus lines' to draw attention to an object, person or element on a page.

Adjustments A Photoshop command/process carried out on artwork and layers to change colour, contrast and tone.

Adobe The company responsible for producing Photoshop as well as other multimedia and creativity software products.

Airbrush shading/soft CG A style of digital art which uses smooth, blended tones like those of a traditional airbrush.

Anatomy The structure of the body and how the various parts are in proportion with one another.

Anime A Japanese style of animation and artwork.

BG An abbreviation of 'Background'.

Cel shading A style of artwork like that of an animation still, which uses solid tones and shading.

CG An abbreviation of 'computer graphics' – often used to describe digitally rendered manga art. CGing is the process of rendering artwork digitally.

Colour modes These allow different colour ranges. CMYK is a suitable mode for art intended for print, while RGB is for art for screens and internet.

Custom brushes These can be downloaded or created for use with Photoshop's Brush tool. They come in a vast number of shapes and sizes with different associated default settings.

Cuts A Western comic-book colouring technique which uses a combination of masks and selections along with airbrush shading to add highlights.

Digital inking Adding clean black outlines to an existing pencil or graphics tablet sketch using computer software.

File formats Artwork image files are typically PSDs (Photoshop files). JPEG, GIF and PNG are used to compress files into a smaller size for web use. TIFF and BMP are occasionally used as flat files with low or no compression.

Flatting The process of adding a solid, flat base tone to layer/s on an image, often within pre-drawn outlines and line art.

Graphics tablet An input device which connects to your computer, allowing you to draw with a pen or stylus instead of a mouse. Often simply referred to as a 'tablet'.

Layers Photoshop layers are like sheets of stacked glass – you can see through transparent areas of a layer to the layers below. You can move a layer, repositioning its content, like sliding a sheet of glass in a pile. You can change the opacity of a layer to make the content partially transparent.

Manga A Japanese style of comics and artwork.

Opacity Another term for transparency. Opacity percentages can be adjusted using Photoshop's tools, options and adjustment settings.

Overlay An effect or colour added to a layer which is situated on top of artwork or shaded elements. In this book, overlay refers primarily to the layer and effect. Photoshop also has a blending mode named Overlay.

Photoshop CS CS stands for Creative Suite. Photoshop is one of several Adobe CS programs. The tutorials in this book are based on Photoshop CS6.

Render A term meaning 'add shading' by, for example, adding shadow to depict the form and shape of an object.

Scanning Importing images and artwork into your computer and converting them to a digital format.

Selection A selection isolates one or more parts of your image.

Shading Adding darker or lighter tones and values to create the effect of shadows, highlights and three-dimensional forms.

Stock image Often a photograph that is licensed for specific purposes. It is used to fulfil the needs of creative assignments instead of hiring a photographer or drawing parts of an image manually. Stock images come with terms of use – if you are paying for such images you may be able to use them in whatever way you please. Royalty-free or no-charge images often require you to give credit to the owner or provide a link to the image source.

Tone A term used to describe a hue and the result of mixing it with any shade of grey.

Workflow The process an artist goes through to achieve his or her results from start to finish or from one step to the next. The more efficient your process, the better your workflow.

ACKNOWLEDGEMENTS

Archer stock photo, page 46: senshi-tock, http://senshistock.deviantart.com

Elise art and image based on original character concepts, page 83: Heli Palmunen, http://volvom.deviantart.com

Clarisse art based on original character concept, page 85: Khaie Allen, http://momoneko-chan.deviantart.com

Floral pattern stock photo, page 92: Oksancia, http://www.oksancia.com

Blue camo pattern, pages 114–115: Mike Soto, http://mikesoto-photography.deviantart.com/

Woodland camo pattern, pages 114–115: Chris Spooner, http://blog.spoongraphics.co.uk

Camo pattern library pack, pages 114–115: Paul Ripmeester, http://silver-.deviantart.com

Bow stock photo, page 121: Random-Resources, http://randomresources.deviantart.com

Lace custom brushes, page 121: Ash Mienne, http://morfinedoll-stock.deviantart.com

Rose stock photo, page 121: dark-rose42-stock, http://www.deviantart.com/art/Red-rose-52246140

Tokyo street stock photo, page 124: Hirolu Erikawa, http://hirolus.deviantart.com/

Fire stock photos, page 131: Marshall Watson, http://thesuper.deviantart.com/

Fur and scales custom brushes, page 132: JL Hirten, http://coyotemange.deviantart.com

Clouds stock photo, page 133: Freebig-pictures, http://freebigpictures.com

Water custom brushes, page 133: Andreea Cernestean, http://frozenstarro.deviantart.com/

Cotton line art creation, page 145: Yoio, http://yioi.deviantart.com/

Zombie love art based on original character concept, page 148: Nayume Page, http://nayume.deviantart.com

Digital inking assistance with line art: Lila Studio, for Yuki, pages 87–93; Justin Silver, pages 111–117; Gothic Lolita, pages 119–125; fire-fighting femme fatale, page 153. http://lilastudio.deviantart.com/

Assistance and proofreading: Kelly Huggins